The Codex Nuttall

The Codex Nuttall

A PICTURE MANUSCRIPT FROM ANCIENT MEXICO

THE PEABODY MUSEUM FACSIMILE EDITED BY

ZELIA NUTTALL

With New Introductory Text by
ARTHUR G. MILLER
The Center for Pre-Columbian Studies, Dumbarton Oaks

Dover Publications, Inc.
New York

Published in Canada by General Publishing Company, Ltd., 30 Lesmill Road, Don Mills, Toronto, Ontario.

Published in the United Kingdom by Constable and Company, Ltd., 10 Orange Street, London WC 2.

This Dover edition, first published in 1975, is a complete color reproduction, in standard book format, of the facsimile screenfold originally published by the Peabody Museum of American Archaeology and Ethnology, Harvard University, Cambridge, Mass., in 1902; this screenfold was accompanied by a booklet written by Zelia Nuttall (not reprinted here) titled *Codex Nuttall, Facsimile of an Ancient Mexican Codex Belonging to Lord Zouche of Harynworth, England.*

All the text in this volume has been written specially for the present edition by Arthur G. Miller.

International Standard Book Number: 0-486-23168-2
Library of Congress Catalog Card Number: 74-83057

Manufactured in the United States of America
Dover Publications, Inc.
180 Varick Street
New York, N.Y. 10014

Preface to the Dover Edition

In the fall of 1973 Mr. Hayward Cirker, President of Dover Publications, asked me to write a general introduction to a reprinting of the facsimile of an ancient Mexican codex published by the Peabody Museum of Harvard University in 1902. The facsimile of the Codex Nuttall which Dover has here reprinted is considered the standard reference for the famous Mexican screenfold now kept in the British Museum.

I had seen recently the original manuscript in England and was impressed with the remarkable quality of the Peabody facsimile. Despite the fact that the Peabody facsimile is a printing of a colored drawing made from the original codex and not a photographic copy, I think the results are more faithful to the original than many photographic facsimiles of Mexican picture books.

The publication of a photographic facsimile of the Nuttall is being considered by the British Museum, and a commentary on the Nuttall, prepared by Alfonso Caso, is to be published in Mexico, possibly accompanied by a facsimile (Donald Robertson, personal communication, 1973). Both of these future publications will be expensive. Therefore I think that it is important that a good and inexpensive facsimile be available for professional archaeologists and art historians, students, and the general public who are participating in the growing interest in the pre-Columbian cultures of Mesoamerica.

I would like to thank Donald Robertson and Susanna Ekholm-Miller for their generous and thoughtful advice on the most effective manner to present a general introduction to the Codex Nuttall. Elizabeth Carmichael, Assistant Keeper of the Museum of Mankind (British Museum), is to be thanked for showing me the original Codex Zouche-Nuttall and for responding to letters concerning the original codex.

Mexico City
January 1974

ARTHUR G. MILLER

BIOGRAPHICAL NOTE

Arthur G. Miller received his doctorate from Harvard University. Formerly a member of the faculty of Yale University, Dr. Miller is currently Research Associate of The Center for Pre-Columbian Studies of Dumbarton Oaks, Washington, D.C. He is the author of a book on the mural paintings of Teotihuacán, the great pre-Columbian city in Central Mexico, and, for the past three years, has been working on recording pre-Columbian murals of the Yucatán Peninsula. Dr. Miller is now directing intensive excavations of the Maya site of Tancah in Quintana Roo, Mexico.

Introduction to the Dover Edition

I. THE NATURE OF THE CODEX NUTTALL

1. THE PEABODY EDITION OF "AN ANCIENT MEXICAN CODEX BELONGING TO LORD ZOUCHE OF HARYNWORTH, ENGLAND"[1]

The Mexican manuscript reproduced in the following pages was first brought to the attention of scholars by Zelia Nuttall. The manuscript was owned by an Englishman known as Lord Zouche. Consequently, references in the published literature to this codex sometimes refer to the ancient work as the Codex Zouche or the Codex Zouche-Nuttall. It was the director of the Peabody Museum of American Archaeology and Ethnology of Harvard University at the turn of the century who gave the name Nuttall to the codex, in honor of Zelia Nuttall's contribution.

With the support of the Boston scholar and benefactor of the Peabody Museum, Charles P. Bowditch, Miss Nuttall had the original manuscript copied by a skilled artist and published in full color in 1902 by the Peabody Museum of Harvard University. The Peabody facsimile of the Mexican manuscript was produced in the format of the original as a screenfold.

Zelia Nuttall's artist rendered the Mexican painted book with remarkable accuracy and the Peabody edition does well in reproducing the colors of the original codex. In general the original colors are more intense than shown in the Peabody facsimile. Also the white of the page in the codex is brighter and cleaner than shown in the Peabody edition. But the drawing and color relationships in the Peabody facsimile are very close to those of the original. The arabic page numbers seen in the facsimile (usually in the upper right corners) are, of course, additions made by Nuttall's artist; these are the numbers

[1] Nuttall 1902: title page.

referred to by all scholars and used in the present Introduction. (Page numbers were also written in arabic numerals on the original codex at some time during its European sojourns.)

In the Peabody edition (followed here) the page numbers 19 and 76 are each given to two contiguous pages since each pair contains a single large scene. The cover design of the Peabody facsimile is omitted in this Dover reproduction as it is a decorative addition and is not to be found in the original.

There are several errata in the Peabody facsimile. The errors include the omission of vertical guidelines for the reader which occur in the folds between two pages and omission of blank pages which appear in the original. These errors do not make the Peabody publication a poor facsimile, as has been suggested by Caso (1966: 15). Omission of vertical guidelines is indicated (after Burland 1957) in this edition in the listing on page xxi. These vertical guidelines are necessary to an understanding of the sequence of events indicated in the codex. For technical reasons the blank pages do not occur in the present edition, either.

The most serious mistake in the Peabody facsimile screenfold is the inclusion of the first two pages of the reverse (back), pages 42 and 43, as the last two pages of the obverse (front). This Dover edition obviates that problem by simply running all the pages in a single reverse order. Included in this edition is the page with four Nahuatl year-bearer names written in a sixteenth-century Spanish script, as this page was part of the original codex when Zelia Nuttall studied it. In the Peabody edition, as here, this page follows page 84 of the reverse, although it is really part of the obverse.

2. THE PRE-COLUMBIAN SCREENFOLD

To call the Nuttall a codex is a misnomer (Kubler 1962: 100; 336). The term "codex" usually refers to European illuminated manuscripts consisting of pages bound on one side. The Nuttall painted book and the other surviving picture books from pre-Conquest southern Mexico, as well as the three surviving Maya pre-Conquest manuscripts,[2] are actually screenfolds of animal skins or bark paper covered with a thin coat of fine lime plaster upon which are painted in various colors, encased in black outlines, the images of the picture book.

The connected pages of these picture books can be stretched accordion-fashion to the shape of a long flat rectangle. When the screenfold is refolded, it forms a compact pile of pages. Each page of the Mixtec codices (of which the Nuttall is one) is divided into horizontal or vertical bands showing a series of figures accompanied by dates and symbols. These images on each page are "read" in a boustrophedon or back-and-forth pattern with red lines indicating the sequence of reading. This is a very different kind of book from a European illuminated manuscript with its lineal text accompanied by illustrations. Despite the inappropriateness of using the term "codex" here, Mixtec picture books have long been referred to in the published literature as "codices," and we will maintain that label in our discussion of the Nuttall and other Mixtec manuscripts to avoid confusion.

Ancient Mexican screenfolds are remarkably versatile as forms of information storage. It is possible to view several pages simultaneously and even to consult the obverse at the same time as the reverse (Kubler 1962: 100). Clearly, the screenfold format was devised as a solution to the need of non-Western, nonlineal patterns of thought. In addition, the screenfolds served as mural paintings: they were stretched out and hung on the wall (Burgoa 1934, Vol. I, p. 288).

It is unfortunate that the economic exigencies of contemporary bookmaking require a Western format to present the Nuttall. How inappropriate and awkward is the bound-book format which does not allow the beginning to be placed next to the end or the front next to the back! Since the Nuttall is read from right to left in boustrophedon pattern, this Dover edition reproduces the pages of the codex in numerically reverse order to make the reading of them as close to the reading of the original screenfold as possible. (This will be further explained on page xxi.)

[2] The three surviving Maya books are the Codex Dresden, the Codex Madrid (also known as the Tro-Cortesianus) and the Codex Paris, named after the cities where they are now kept.

3. The Mixtec Histories

There are eight surviving examples of the group of stylistically and iconographically related pre-Conquest codices of which the Codex Nuttall is one. The others are the Codices Bodley and Selden (Bodleian Library, Oxford), the reverse of the Codex Vienna (Nationalbibliothek, Vienna), the Codex Colombino (Museo Nacional de Antropología, Mexico City), the Codices Becker I and II (Museum für Volkerkunde, Vienna) and the Codex Sánchez Solís (Egerton 2895, British Museum) (Smith 1973: 9).

Zelia Nuttall was the first to suggest that the codex that bears her name depicted the lives and conquests of individuals, who she thought were Aztec warriors. In 1912 J. Cooper Clark discussed the historical nature of what we now call the Mixtec histories but assigned their authorship to the Zapotecs, a major Indian group in south central Mexico. In 1926 Richard Long discussed in more detail the historical nature of the Codex Nuttall and in 1935 Herbert Spinden demonstrated that one of the Mixtec histories, Selden II, was concerned with the life of a princess (Caso 1949: 147–48; 1965: 948–50). It was the distinguished Mexican scholar Alfonso Caso who first found evidence to demonstrate that the eight manuscripts mentioned above come from south central Mexico, specifically the region of present-day Oaxaca, and are genealogical and historical in content; he provided the key to "reading" the Mixtec histories. Caso did this in a remarkable paper published in 1949 in which he proved that the rulers listed in these eight books came from towns named Tilantongo and Teozacoalco in the State of Oaxaca. These towns were in pre-Columbian times (and still are) included within the linguistic region of Mixtec speakers (sometimes referred to as the Mixteca). Genealogical tables of these rulers are the subject matter of these pre-Conquest Mixtec histories. Also shown are births, marriages, deaths, political events, wars, conquests, alliances and religious fiestas of Mixtec dynasties. Caso demonstrated that the history of the Mixtec kings shown in these codices dates as far back as A.D. 692. Because of the subject matter of these eight surviving codices they are referred to as the Mixtec genealogical-historical manuscripts (Smith 1973: 9).

In his famous 1949 paper Caso also demonstrated that the Mixtec histories contained information "relating the divine ancestors of the kings and so constitute a true theogony. The earthly histories have a heavenly prologue" (Caso 1965: 950).

4. The Ritual Books

There is another group of six pre-Conquest painted picture books in a style similar to the Mixtec genealogical-historical manuscripts. This group is commonly referred to as the Borgia group, so named after the most important of the six, the Codex Borgia (Vatican Library, Rome) (Robertson 1966: 298). The other five surviving manuscripts are the Codex Laud (Bodleian Library, Oxford), the Codex Fejérváry-Mayer (Liverpool Free Public Museum), the Codex Cospi (University Library, Bologna), the Codex Vaticanus B (Vatican Library, Rome) and Mexican Manuscript No. 20 of the Bibliothèque Nationale in Paris (Robertson 1966: 298).

The subject matter of these ritual manuscripts does not pertain to genealogies and histories of specific persons and areas as do the eight historical books mentioned above. Instead, these six surviving ritual manuscripts in Mixtec style pertain to complex and still poorly understood pan-Mesoamerican cosmogony and cosmology as well as to ritual beliefs and practices based on an augural calendar of 260 days which was shared by all Mesoamerican peoples during the Postclassic period (after 1000 A.D.). This is the most significant reason why scholars have not been in agreement as to the place of origin within Mesoamerica of the Borgia group. One suggestion as to the origin of the Borgia group is the Puebla-Tlaxcala area near the Valley of Mexico (Caso 1965: 950). Robertson (1966) presents convincing arguments for the south central Mexican Mixtec area, the home of the Mixtec histories, as the origin of the Borgia group.

The following discussion of the Codex Nuttall falls into three parts. First, there is a description of the provenance of the Codex Nuttall, in which the history of the original manuscript is briefly traced. Second, there is a discussion of the style of the Codex Nuttall. Finally, the most salient aspects of the iconography of the codex are examined.

II. THE PROVENANCE OF THE CODEX NUTTALL

1. RECENT HISTORY

The Codex Nuttall is now kept in the Museum of Mankind (British Museum). In 1898 Zelia Nuttall first examined the codex in the British Museum, where it was being kept by its custodian, Sir Edward Maunde Thompson (Nuttall 1902: 4). In her introduction to the Peabody facsimile, Zelia Nuttall (1902: 1–5) traces the history of the codex. It is known that "the Codex was presented as a gift [from an Italian friend] to the Hon. Robert Curzon, 14th Baron Zouche . . ., who had brought together in his library at Parham, County of Sussex [England], a most interesting and valuable collection of rare manuscripts 'to illustrate the history of the art of writing.' "

When Robert Curzon died in 1873 the codex passed into the possession of his son, who was known as the 15th Lord Zouche. It was this Lord Zouche who gave the permission to the Peabody Museum to begin making a facsimile edition in 1898. In 1901 the work (by an anonymous artist) of copying the codex was completed. This original color rendering was printed in 1902 by the Peabody Museum.

Mrs. Nuttall mentions that it was in Florence that she first learned of the existence of the ancient Mexican codex. Apparently the manuscript had once formed part of the library of the Monastery of San Marco in that city. The manuscript was sent from Florence to Rome to be examined by Church authorities. In Rome it was not highly esteemed: " '. . . the document was probably intended for the amusement of children but was so foolish that it could only bore them' " (Nuttall 1902: 2).

It appears that the codex was sent during the second half of the nineteenth century to England. The codex was not the first ancient Mexican picture book to reach England. The first publication of a Mexican codex appeared as early as the eighteenth century. Mexican codices were most probably known by 1831 among the educated classes in England as a result of a splendid publication by a wealthy Englishman who developed a passion for the study of Mexican antiquities. That publication was the first volume of *Antiquities of Mexico*, which includes two of the ancient Mexican codices. The Englishman responsible for the publication was Lord Kingsborough.

In London, as well as in Rome, the nineteenth century found little to admire in the ancient Mexican manuscripts which reached their libraries. In a 1833 lecture on the history of painting which John Constable, the well-known English landscapist, delivered to the Royal Academy of Art in London, there is an interesting reference to ancient Mexican manuscripts, characteristic of the taste of a time which still admired the works of neo-Classicism. In discussing the Bayeux Tapestry, which Constable considered a nadir in the history of European pictorial art, Constable cites one kind of painting which he considers more debased, the Mexican codices he probably saw reproduced in Kingsborough: ". . . the Bayeux tapestry, which is indeed little better than a Mexican performance . . ." (Leslie 1937: 376; Smith 1973: 21).

2. EARLY HISTORY

As with all the pre-Columbian painted screenfolds, the early history of the Codex Nuttall is obscure. Prior to the appearance of the manuscript in the Dominican monastery of San Marco in Florence in 1859 nothing is known of its history (Smith 1973: 12).

It has been suggested that the Codex Nuttall may have formed part of the famous "Moctezuma treasure" which was sent by Cortés to Charles V in 1519 (Nuttall 1902: 9–11; Smith 1973: 12).[3] It is possible that the Nuttall is referred to in Cortés' First Letter to Charles V in which he mentions that he is sending among other things "two books such as the Indians have (dos libros delos que tienen los yndios)" (Smith 1973: 12). The other picture book may have been the manuscript that is preserved in the Nationalbibliothek, Vienna,

[3] Eric Thompson (1972: 3–4) argues that the Nuttall was not part of the shipment to Charles V.

and that is referred to as the Codex Vienna. This codex is a Mixtec screenfold which is very close in style to the Nuttall (Robertson 1966: 302; Smith 1973: 11–12).

III. THE STYLE OF THE CODEX NUTTALL

1. COMMON STYLISTIC TRAITS IN THE NUTTALL AND ALL THE MIXTEC GENEALOGICAL-HISTOR-ICAL MANUSCRIPTS

Many of the characteristics of style found in the Nuttall screenfold also apply to all the genealogical-historical manuscripts as well as to the ritual manuscripts. Perhaps the most obvious common trait is the screenfold format. Another is the boustrophedon reading pattern with red lines indicating the sequence of reading. Still another can be seen in the explanatory mode of drawing which presents simply and clearly profile views and full frontal views of people, animals, costumes, ornaments and architecture. Things are shown in their clearest, most identifiable aspect. The images depicted exist in a two-dimensional world with not even the use of overlapping to suggest space; clarity of the images is more important than their appearance in relation to the natural world. This kind of pre-Columbian picture making is directly linked with a visual mode of expression which I have described elsewhere as being presentational rather than representational (Miller 1973). Another way of putting it would be to state that the Mixtec manuscripts are conceptual rather than perceptual modes of visual expression. Ideas and concepts rather than the natural world are given visual form.

A. CONCEPTUAL VISUAL EXPRESSION This presentational or conceptual mode of visual expression which is characteristic of the Mixtec manuscripts can be seen at the lower right-hand corner of page 5 of the Nuttall. We see a side view of a huge human figure dressed in an eagle costume emerging from a cleft in an ornate temple pyramid. A small squatting figure is shown in profile at the base of the pyramid. The eagle man is of immense size in proportion to the temple. The seated figure below is depicted as a dwarf in comparison with the eagle man. This manner of presenting images refers not to a giant and a dwarf but to a hieratic scheme in picture making. The size difference of the figures signifies the relative status of the figures in the eyes of the Mixtecs. The eagle man who is shown large is more important than the crouching figure and the ornate temple, which are shown relatively small. Such a scheme of visual expression has little to do with the way things appear in the natural world.

Facing the huge seated eagle man shown at the lower right-hand corner of page 5 is a standing figure dressed in complex costume. The figure is important because of the space he occupies in the scene. He wears a fantastic head costume combining feline and bird features and an axe near his ear as well as a shirt with black spots on a white ground and a fringed skirt and sandals. The standing figure holds an ornate bird in his right hand. His left hand and forearm are shown higher but on the same plane as his right hand and forearm. The figure's left hand holds a symbol for an offering of some kind. The costume and the objects held in the hands of this standing figure are all shown in their clearest, most identifiable aspect: in this case, in profile view. Showing objects in clear profile (or frontal) view is another important aspect of the conceptual art of the Nuttall and all the Mixtec codices.

Although the feet of this standing figure suggest a profile view, the torso is shown in partial frontal view. In the natural world the figure's right hand and forearm would be on a different plane from the figure's left hand and forearm. Placing on a single plane forms which would in the natural world be on two or more planes is another aspect of conceptual or presentational art that we see in the Nuttall and that is typical of the Mixtec codices in general.

Below the standing figure is a painted skull with six dots to the left of it. Next to the skull and below the small crouching figure at the base of the temple is a stylized lizard head with a dot attached to the nose by a black line. Directly below the temple are a large interlaced "A" and "O" with an arrow through them. A dot is attached to this symbol by a black line.

These floating images are symbols shown large in proportion to the figures in the scene above and are therefore hieratically important. These symbols pertain to calendar names of individuals based on an augural calendar of 260 days and a date in the solar year of 365 days. Names and dates referring to the figures were of great importance in the Nuttall and all the Mixtec codices and are conspicuously presented to the viewer on the page.

Although individual persons are very important in the Mixtec manuscripts, there is no portraiture: "In Mixtec manuscripts persons are identified by their names, not by their physical features" (Smith 1973: 11).

If we turn to page 6 of the Nuttall we see that the Mixtec sense of *horror vacui* is very obviously evident. The figures and their accompanying name symbols are evenly spaced over the page so that the background white area does not predominate in any one portion, but is equally evident over the entire surface.

Page 6 also demonstrates that, in general, the heads of figures shown in the Mixtec codices are always large in proportion to the rest of the body. Costume ornaments and other objects of dress associated with a figure are shown in detail so that the person can be clearly identified as to his rank and function (Clark 1912: 5). The human body as seen on page 6 is shown ". . . as a compendium of separable parts" (Smith 1973: 11). The enlargement of the most important part of the body, the head, and the breaking up of the body into symbolic units are characteristic hallmarks of conceptual visual expression evident in the Mixtec genealogical histories.

B. LINE AND COLOR On page 53 of the Nuttall one can examine two of the most distinctive traits of Mixtec manuscript painting: line and color. A thin wiry black outline encases the flat color areas in the same way that cloisons surround enamel or lead surrounds stained glass (Robertson 1959: 16). This bounding outline is not a hard unvarying mechanical line. Instead, the Mixtec line is a freehand line which varies in width and therefore gives a quality of life to the unvarying flat color areas it encases. (But Mixtec line does not show three-dimensional form.) This quality of the bounding line can be seen in the three stylized brown hills depicted in the middle of page 53.

In addition to this ever-present bounding line, there are lines inside of the flat color areas which "qualify, symbolically, the areas of color thus enclosed" (Robertson 1959: 16). We can see this in one of the rounded brown hills to which we referred above: it is modified by black vertical wavy lines suggesting flowing water or snow on a mountain top. Vertical hatching of fine black lines symbolizes the thatch roof in the temple shown at the upper left-hand corner of page 53. Short interior black lines characterize the feathers of the bird shown pierced by an arrow at the lower right-hand corner of page 53. Rows of short black lines characterize the hair of the rabbit head depicted directly above the pierced bird.

Another common characteristic of Mixtec line is its quality of doing "double duty" (Robertson 1959: 16): a single line enframes two color areas and separates two shapes at the same time. At the lower left-hand corner of page 52 of the Nuttall we see a seated black-clad figure undergoing the Mixtec rite of having his nose pierced (a mark of distinction). There is one line which forms the frame for the color areas of the black body and the throne.

In order to complement the draftsmanship of the codices, a particular use of color was adapted by the Mixtec painters. Color areas in the Nuttall, as in all the Mixtec codices, have no modeling or shading. The intense unbroken solid colors of the Mixtec codices reinforce the two-dimensional flatness suggested by the drawing. No color reproduction can approach the intensity and brilliance of Mixtec pigments which can be seen in the original Nuttall Codex, although the color we see reproduced on page 52 of the Nuttall is a close approximation of the original. Page 52 is also a good example of the use of white in Mixtec codices; the finely stuccoed white background of the page is left bare in some areas of the figures and is made a positive shape by the bounding black outline.

C. MOTION AND EMOTION Although the parts of the body of people and animals are shown articulated in the Mixtec codices, very little motion or emotion is indicated. People and animals are frozen into one unalterable position. There is little suggestion of any more possible movement than just what is shown. This symbolic mode of presenting images is appropriate to the subject matter it describes: the inalterable, incontrovertible historical and mythical past. This

mode leaves little room for the depiction of the transience and uncertainty of human emotion. At the top of page 52 two famous Mixtec warriors confront a fantastic bundle-like object (probably a sign for a place) in symbolic battle. The only suggestion of emotion is seen in the bared teeth of the confronting figures, which look more like the inlaid teeth of a mask than the snarling expression of human beings bent on destructive action. At the lower right of page 81 is shown a sacrifice by heart extraction. The facial expression of the executioner and victim hardly give the impression of all the human emotion that would be involved in such a terrible situation.

To have depicted movement, hate, suffering or joy in the Mixtec genealogical histories would have been to dwell on the most characteristic aspect of the human condition, that of being subject to change. For the pre-Columbian mind, the past—historical or mythical—was unlike the present in its quality of being finite. History, like the gods, cannot change. In relating the past in visual form as being incontrovertibly unchangeable, the pre-Columbian painters of the Nuttall and other Mixtec genealogical histories effectively deified the historical personages depicted in the manuscripts.

2. Stylistic and Technical Traits of the Codex Nuttall

A. STYLE The Nuttall deerhide screenfold is 11.22 meters in length. It has 47 pages on each side of the screenfold, making a total of 94 rectangles or pages, each measuring 25.5 centimeters in width and 18.8 centimeters in height. Eighty-six of the pages have images painted on them.

There are two distinct styles of drawing represented by the two sides of the Nuttall. The colors of the obverse, which includes pages 1–41, are a light and dark red, blue, yellow, green, purple, brown, black, gray and the white of the stucco surface. The colors of the reverse, which includes pages 42–84, are similar, with the addition of yellow-orange instead of yellow and green (Robertson 1959: 17). The obverse is dark in tonality and dense in composition while the reverse is lighter in tonality and more open in composition.

There is a particular manner of page organization in the Nuttall,

characterized by the use of vertical guidelines which divide each page into three or four vertical rectangles. In general the images on each page of the obverse and reverse are read from the bottom right-hand corner up to the top of the vertical guideline closest to the right-hand edge of the page and then down and up again at the next vertical guideline, or from upper right down to the end of the vertical guideline closest to the right-hand edge of the page, then up and down again at the next vertical guideline. Variations and irregularities to this scheme exist, but if one follows the meander indicated by the red lines and if one remembers that the sequence of events—like the entire codex—is connected, it is difficult to get lost.

Stylistically, the obverses of both the Codex Nuttall and the Codex Vienna resemble each other (Smith 1973: 11). Figural style and draftsmanship and the use of vertical guidelines are the most obvious stylistic similarities between the two codices.

On the basis of the stylistic traits mentioned above the Nuttall is dated as unquestionably a pre-Conquest manuscript.

B. TECHNIQUE The painting technique of the Nuttall obverse is remarkably like that of mural painting of the Postclassic period. This should not be surprising since Mixtec codices are foldable mural paintings which were hung on the walls of Mixtec houses. Upon a smooth prepared surface of lime stucco, a preliminary red line of the design was sketched, then the solid colors were blocked in from light to dark and, finally, the black outlines were applied. In the original codex (for example on page 28) I found some evidence of dark red and purple having been placed over the black outlines. This suggests that in some cases these two colors were applied last, after the black outlines.

The painting technique of the reverse is different from that of the obverse. I found no evidence of preparatory red outlines. Instead, black outlines first define the image, followed by the filling in of colors in the areas defined. There is no apparent sequence of color application as in the obverse. Pages 49 and 64 show unfinished sections revealing the first stages of the simple painting technique of filling in black-outlined areas. Pages 47, 48, 53 and 54 of the reverse show light-gray sketchy outlines. These latter lines have nothing to do with the painting technique and are later additions. The glosses writ-

ten in European script that appear on many pages of the codex are also later additions.

The pigments used in the Nuttall have never been analyzed chemically. Based upon knowledge of the chemical composition of the Codex Colombino (Torres 1966: 89–99) and analysis of the Codex Selden (Dark and Plesters, 1959), the pigments used in the Nuttall are most probably mineral colors found naturally.

A Mixtec-manuscript scholar who has been systematically studying Mixtec codices in European collections has found incontrovertible evidence that the reverse of the Nuttall was painted before the obverse (Troike 1969; Smith 1973: 12). This discovery was made by observing tiny holes in the manuscript. Paint from the front of the manuscript has passed through the holes to the back and appears on top of the paint on the back.

IV. THE ICONOGRAPHY OF THE CODEX NUTTALL

1. Iconographic Conventions Common to the Mixtec Codices

Certain iconographic conventions found in the Nuttall screenfold apply also to all the Mixtec manuscripts. Perhaps the most essential is the use of the Mesoamerican calendar. Another is the system of writing that is found in all the Mixtec histories.

A. THE MIXTEC CALENDAR From about the first half-millennium before Christ through the time of the Conquest of Mexico, the calendar had a similar structure throughout Mesoamerica. The Mixtec calendar, a local version of the Mesoamerican system of notating the passage of time, is similar in organization to all Mesoamerican calendars. It consists of a ritual cycle of 260 days called the *tonalpohualli* (this is an Aztec term; the Mixtec term is not known), a solar cycle of 365 days (called the *cuiya* in Mixtec), and a "century" of 52 years (called *eedziya* in Mixtec) (Caso 1965: 955).[4]

Dates in the solar year are given in all the Mixtec histories. They are given by a "year sign"—an interlaced "A" and "O"—in which one of four day signs that function as "year bearers" is affixed along with a numerical coefficient. There are four year-bearer signs: "House," "Rabbit," "Reed" and "Flint." These are combined with numbers from one to thirteen in a cycle of 52 years. "Thus any given Mixtec date may occur once every fifty-two years. For example, 1970 is a Nine-Rabbit year in the Mixtec calendar, but so were 1918, 1866, 1814 and so on, at fifty-two year intervals" (Smith 1973: 22). It has been suggested that the interlaced A–O year sign represents a sun-ray sign bound by a rope (Smith 1973: 22).

The days in the Mixtec codices are expressed by twenty day signs combined with numerical coefficients 1–13 expressed by dots. Twenty times 13 is 260, a complete cycle in the Mesoamerican and Mixtec augural year. The twenty day signs are clearly shown on pages 24 and 25 of M. E. Smith's *Picture Writing from Ancient Southern Mexico* (Smith 1973). These day signs and their accompanying dots can be seen on every page of the Nuttall.

A Mexican, Wigberto Jiménez Moreno, was the first scholar to correlate the Mixtec calendar with our system of dating (Jiménez Moreno 1940: 69–76; Smith 1973: 22). A few years later, another Mexican scholar, Alfonso Caso, demonstrated that the eight known genealogical-historical manuscripts cover almost 900 years of history beginning as early as 692 A.D. and ending at 1556 A.D. (Caso 1949; Smith 1972: 22).

B. MIXTEC WRITING The "writing" employed in the Mixtec histories is an ingenious system of images and pictographic symbols or signs used to convey genealogical and historical information. There are three categories of images, signs or symbols employed: iconographic, ideographic and phonetic (Caso 1965: 951).

The iconographic aspect of Mixtec manuscript writing refers to recognizable images of people, things and situations. This can be seen on page 75 of the Nuttall, which presents a schematic scene of three warriors on raft-like boats on a body of water. The water contains

[4] For a clear and concise general description of the Mesoamerican calendar, see Weaver 1972: 102–106.

fantastic lizard-like and snake-like creatures. Shown also is a bird-fish and painted univalve and bivalve shells. The water-borne warriors are dressed in elaborate battle gear. Carrying weapons (shields, spears, darts and an *atlatl* or dart thrower) and poised for action, the warriors approach a stylized hill. The images of water, creatures in the water and warriors on the water, as well as the stylized hill, are all more symbolic than real. Nevertheless, the general meaning of the scene is intrinsic in the images: a hill-like place is being attacked by armed warriors who approach the place over a body of water.

Inextricably linked to the iconographic aspect of Mixtec manuscripts is the use of ideographic symbols. The meaning of such a symbol derives from the idea which the symbols convey. In a sense, ideographic expression is a shorthand version of iconographic expression. An example of ideographic expression is the brown hill-like shapes with arrows piercing them that are found throughout the reverse of the Nuttall. If we accept the hill as a symbol for place, the arrow piercing it gives us the idea that the place has been attacked militarily. In fact this is an ideograph for a conquered place.

Perhaps the most important examples of ideographic expression are the symbols used in the Mixtec codices to convey the calendar names and second names of the Mixtec lords. The most famous of these ideographs is the head of a deer and a string of eight dots which we find again and again on the reverse of the Nuttall. This is the calendar name for the principal character in the Mixtec histories, 8-Deer. The sign of a deer's head and eight dots signifies the day 8 deer in the Mixtec calendar (it is similar, although not directly equivalent, to saying July 23rd in our calendar). Placing the ideograph of a deer's head and eight dots near the image of a lord signifies that he was born on that day in the Mixtec calendar and was known by that name. 8-Deer's other name was "Tiger Claw." The ideograph for his second name can be seen on page 45 of the codex.

The last and least-understood category of Mixtec "writing" is that of phonetics. Pictographic phonetic "writing" used in the Mixtec codices refers to sounds or words in the Mixtec language. The reference to the meaning of the symbol is therefore not direct as it is in iconographic or ideographic expression.

In Mixtec codices, phonetic signs are employed to designate places.[5] Although there are over 200,000 living Mixtec speakers in western Oaxaca today who still refer to towns and places in the Mixteca by ancient names, most of the phonetic place signs still remain undeciphered. The iconographic and ideographic aspects of the codices are understood to the point that we now have a general idea of what events took place and who participated in them. The limitations of our understanding of phonetic place signs in the histories gives us "very little idea of *where* the participants lived or where the events occurred. At least several hundred place names are depicted in the historical codices; only about twenty place signs have been identified" (Smith 1973: 36).[6]

An ". . . example of phonetics is evidenced by the identity of the Mixtec words for 'plain' and 'feathers'; both are *yodzo*. 'Plain' in the codices is represented by a feather mantle. Thus, the name for Coixtlahuaca, or *Yodzo Coo*, is translated as 'Plain of the Serpent,' and is represented by a serpent on a kind of feather mantle" (Caso 1965: 951).

2. READING THE CODEX NUTTALL

The most significant, at least the best-understood, subject matter of the Nuttall screenfold is that which depicts and describes by means of iconographic, ideographic and phonetic symbols the events in the life of a great military and political hero from south central Mexico: 8-Deer Tiger Claw. 8-Deer Tiger Claw was the second ruler of the second dynasty of Tilantongo. He lived from 1011 A.D. to 1063 A.D.

In the famous article "El mapa de Teozacoalco" (Caso 1949), which led to so much of our understanding of the Mixtec histories,

[5] ". . . Place signs are logograms which cannot be understood until their specific pictorial motifs are associated with specific words in the Mixtec language" (Smith 1973: 22).

[6] M. E. Smith has effectively characterized ". . . many of the conventions used to impart information in the Mixtec histories . . ." (Smith 1973: 34). Professor Smith's characterization of the pictorial conventions of the Mixtec histories (pp. 20–35) is recommended as an excellent presentation of the nature of Mixtec "picture writing."

information concerning the Codex Nuttall is given. The obverse of the Nuttall (pages 1–41) contains genealogical information about the Mixtec lords from 838 A.D. to about 1330 A.D. The reverse (pages 42–84) is our best source for the exciting life of the great Mixtec lord 8-Deer. The Nuttall reverse depicts the story of 8-Deer from the first marriage of 8-Deer's father in 992 A.D. to 8-Deer's sacrifice in 1050 A.D. of two individuals who had sacrificed his half-brother (Smith 1973: 11).

Shortly before his death in 1970, Alfonso Caso had "translated" the entire Codex Nuttall. I include here a sample of his translation of the Nuttall which has already been published (Caso 1965: 960–61), along with some of his introductory remarks, to give the reader an idea of how the Nuttall was read by one of the greatest minds in Mexican archaeology and history.

The Mixtec scribes offer considerable information about the rulers of each place. First they gave the name and the surname, the day and year of birth, their parents, and their wife. Also cited are the names of the parents of their wives and their birthplaces, the names of their brothers and sisters and whom they had married, and the names of their sons and daughters. Let us read a page from the Codex Zouche-Nuttall which contains genealogical data and another page which contains historical data.

On page 26 of Zouche-Nuttall . . . the reader begins in the upper right corner and goes down this column, passes to the second column which is between two red lines, ascends this column to where the red line is interrupted, and then descends the left-hand column.

In the first column is a palace in which is seated a lord, called ♂ 5 Crocodile (the 6 is mistaken), and a lady, ♀ 9 Eagle. He is wearing a mask of Tlaloc, the god of rain, and is carrying the sun on his back. His surname would be "Sun of Rain." From her comes her surname, "Garland of Cacao Flowers." Facing each other indicates they are married. The date is the year 6 Stone and the day 7 Eagle. According to our calculations, this year would be A.D. 992. Below appear the three children of this couple: the first son ♂ 12 Motion "Bloody Tiger," born the year following their marriage, in 7 House, A.D. 993; the second son ♂ 3 Water "Heron"; and a daughter ♀ 3 Lizard "Jade Ornament."

Turning to the second column, we see another palace in which is seated a lone lady called ♀ 11 Water "Bluebird-Jewel." She is the second wife of ♂ 5 Crocodile "Sun of Water"; the date of their wedding was the day 6 Deer of the year 10 House, A.D. 1009, or 17 years after his first marriage. In the year 12 Cane, A.D. 1011, in the day 8 Deer, their first son was born, called ♂ 8 Deer "Tiger's Claw," the most famous king the Mixtecs had, who reigned in Tilantongo and Teozacoalco and conquered many places. Then come the births of his younger brother, ♂ 9 Flower "Copal Ball with an Arrow," in the year 3 Cane, A.D. 1015, and his sister ♀ 9 Monkey "Clouds–Quetzal of Jade," in the year 13 Stone, A.D. 1012. Although older than ♂ 9 Flower, she is mentioned last, being a woman.

Descending the third column of this page, we see another palace and in it the lord ♂ 8 Deer "Tiger's Claw" and the lady ♀ 13 Serpent "Serpent of Flowers" who is offering him a bowl of chocolate, symbolic of marriage. The date of this is the day 12 Serpent of the year 13 Cane, A.D. 1051; thus, when "Tiger's Claw" married he was already 40 years old. The page ends with mention of the birth of his two sons: ♂ 4 Dog "Tame Coyote" in the year 7 Rabbit, A.D. 1058, and ♂ 4 Crocodile "Serpent Ball of Fire" two years later in 9 Stone, A.D. 1060. Thus ends page 26 of the Zouche-Nuttall codex.

On pages 83 and 84 of the same codex . . . we see an example of a nongenealogical narrative. The reading is in the same manner, beginning in the lower right corner. The year 11 House and the day 12 Monkey is A.D. 1049. On the day 12 Monkey, ♂ 8 Deer "Tiger's Claw" conquers a place whose name we do not know, but whose glyph is called "God Xipe's bundle." The conquest of this place, which appears also in other codices (Colombino, Becker II, and Bodley), puts to an end a long dynastic war. Here we see ♂ 8 Deer "Tiger's Claw" making prisoner the youngest prince of this place, only nine years old and called ♂ 4 Wind "Serpent of Fire." He also captures the older brothers, the princes called ♂ 10 Dog "Eagle Copal Burning" and ♂ 6 House "Row of Flint Knives." In the following year, 12 Rabbit, A.D. 1060, on the day 6 Serpent ♂ 8 Deer, disguised as a red tiger, and probably his brother, ♂ 9 Flower, disguised as a yellow tiger, engage in a sacrificial gladiatorial combat with the prince ♂ 10 Dog "Eagle Copal Burning" and another warrior disguised as death. He (♂ 8 Deer) kills the other prince, ♂ 6 House "Row of Flint Knives," by shooting him eight days later, on 1 Cane. . . .

Besides the ceremonies mentioned on page 84 of the codex are those that occur on the days 9 Wind and 2 Buzzard and consist of the de-

capitation of quail, ritual offerings of pulque and cacao, and the burning of bones, probably those of the sacrificed princes.

The Codex Nuttall is the best-known and the most thoroughly understood pre-Conquest Mexican manuscript in existence today. The reason that the Nuttall is comparatively so well understood is, of course, because it was so well known. And we owe that to its early publication by the Peabody Museum in 1902, a publication which has resulted in exposing the ancient Mexican codex to the eyes and minds of many students, scholars and generally interested individuals who have contributed to an understanding of the Nuttall during the last three quarters of a century. This Dover edition of the famous Peabody facsimile makes the Nuttall even more widely available and it is hoped that this edition will result in contributions that will add further to our knowledge.

REFERENCES CITED

Burgoa, Francisco de
1934 *Geográfica descripción.* 2 vols. Publicaciones del Archivo General de la Nación, Vols. XXV–XXVI. México.

Burland, Cottie A.
1957 "Some Errata in the Published Edition of Codex Nuttall." In *Boletín del Centro de Investigaciones Antropológicas de México.* Vol. 2, No. 1, pp. 11–13. México.

Caso, Alfonso
1949 "El mapa de Teozacoalco." In *Cuadernos Americanos,* Año VIII, No. 5, pp. 145–81. México.

1965 "Mixtec Writing and Calendar." In *Handbook of Middle American Indians,* Vol. 3, Part 2, pp. 948–61. University of Texas Press. Austin.

1966 *Interpretación del Códice Colombino.* Sociedad Mexicana de Antropología. México.

Clark, J. Cooper
1912 *The Story of "Eight Deer" in Codex Colombino.* Taylor and Francis. London.

Dark, Philip, and Joyce Plesters
1959 "The Palimpsests of Codex Selden: Recent Attempts to Reveal the Covered Pictographs." In *XXXIII International Congress of Americanists,* Vol. II, pp. 530–39. San José de Costa Rica.

Jiménez Moreno, Wigberto, and Salvador Mateos Higuera
1940 *Códice de Yanhuitlán.* Museo Nacional. México.

Kubler, George
1962 *The Art and Architecture of Ancient America.* Penguin Books. Baltimore.

Kingsborough, Edward King, Lord
1831 *Antiquities of Mexico: Comprising Facsimiles of Ancient Mexican Paintings and Hieroglyphs,* Vol. 1. London.

Leslie, C. R.
1937 *Memoirs of the Life of John Constable, R.A.* London.

Long, Richard C. E.
1926 "The Zouche Codex." In *Journal of the Royal Anthropological Institute of Great Britain and Ireland,* Vol. LVI, pp. 239–58. London.

Miller, Arthur G.
1973 *The Mural Painting of Teotihuacan.* Dumbarton Oaks, Trustees for Harvard University. Washington, D.C.

Nuttall, Zelia
1902 *Codex Nuttall, Facsimile of an Ancient Mexican Codex Belonging to Lord Zouche of Harynworth, England.* Peabody Museum of American Archaeology and Ethnology, Harvard University. Cambridge, Massachusetts.

Robertson, Donald
1959 *Mexican Manuscript Painting of the Early Colonial Period; The Metropolitan Schools.* Yale University Press. New Haven.

1966 "The Mixtec Religious Manuscripts." In *Ancient Oaxaca; Discoveries in Mexican Archaeology and History,* pp. 298–312. Stanford University Press. Stanford.

Smith, Mary Elizabeth
1973 *Picture Writing from Ancient Southern Mexico; Mixtec Place Signs and Maps.* University of Oklahoma Press. Norman.

Spinden, Herbert J.
1933 "Indian Manuscripts of Southern Mexico." In *Annual Report of the Smithsonian Institution, 1933,* pp. 429–51. Washington, D.C.

Thompson, J. Eric S.
 1972 *A Commentary on the Dresden Codex, A Maya Hieroglyphic Book*. American Philosophical Society. Philadelphia.

Torres, Luis
 1966 "Estudio de los pigmentos." In *Interpretación del Códice Colombino*, pp. 91–99. Sociedad Mexicana de Antropología. México.

Troike, Nancy P.
 1969 "The Provenience of the Mixtec Codices Nuttall and Colombino-Becker." Paper presented at the 68th Annual Meeting of the American Anthropological Association, held in New Orleans, November 20–23, 1969.

Weaver, Muriel Porter
 1972 *The Aztecs, Maya, and Their Predecessors; Archaeology of Mesoamerica*. Seminar Press. New York and London.

The Codex Nuttall

A Note to the Reader

ON PAGE SEQUENCE AND EMENDATIONS

The painted pages of the Codex Nuttall are here reproduced in numerically reverse order to make the reading of them as close to that of the original screenfold as possible (without the necessity of turning the book around halfway through). The codex is read from right to left in a boustrophedon pattern. The reader is therefore asked to turn to codex page 1 (at the end of this bound book) and to read the color pages straight through from right to left and from back to front.

In the original codex, there is a blank page on the obverse that precedes page 1. Page 41 completes the painted obverse and is followed by four unpainted pages prepared for painting. On the second of these four blank pages are the following Aztec year-bearer names (in incorrect order) written in European script:

1 Ce Acatl
2 Ome tochtli
3 Yei tecpatl
4 Navi calli

The page with these names is reproduced here immediately after this Note.

Pages 42–84 represent the painted reverse of the Codex Nuttall. In the original codex, page 84 is followed by three blank pages, the second of which bears the following legend:

Storia Mejicana
99 pages. Aug. 1919 C.J.C.
Examined by C.J.C.

The following errors (omissions of guidelines) in the Peabody facsimile of the Codex Nuttall (photographically reproduced here), have been ascertained by comparison with the original screenfold:

Page 4: The original shows a red line at the bottom right edge of the page (between pages 3 and 4) extending up to the level of the stand-

ing figure's feather headdress. This ensures the sequence of reading and prevents any confusion as to the place of 7-Wind, Eagle Chief, in the story.

Page 13: The original shows a red line extending the entire left-hand edge of the page. This completely separates the genealogical material on page 13 from the saga of Lady 3-Stone Knife, which begins on page 14.

Page 26: The original shows a red line extending from the top of the left-hand edge of the page down to the level of the roof of the temple. This is necessary to indicate the sequence and prevents any confusion about the facing figures on page 27, especially the one which is seated in a palace.

Page 29: The original shows a red line extending from the bottom of the right-hand edge of the page up to the lowest horizontal red band on the tail of the serpent dress of 9-Wind. This is necessary to indi-cate the sequence and it separates the blood-spouting war banner on page 28 from the marriage scene on page 29.

Page 35: The original shows the vertical red line at the left edge extending all the way to the top of the page to mark the conclusion of the story on this page.

Page 36: The original shows that the red patch on the "shoulder" of the serpent joins the red patch on the right edge of page 37. This emphasizes the continuity of the two scenes.

Page 39: The original shows that the red vertical line at the right edges should have been omitted. The yellow member of the path is continuous from page 38.

Page 41: The original shows a red line extending from the top of the right edge of the page to the lowest of the first ten numeral dots in the name of 12-Deer. This line indicates the end of the obverse side of the codex.

1 ce a calli
2 ome tostilli
3 yei tecpatl
4 naui calli

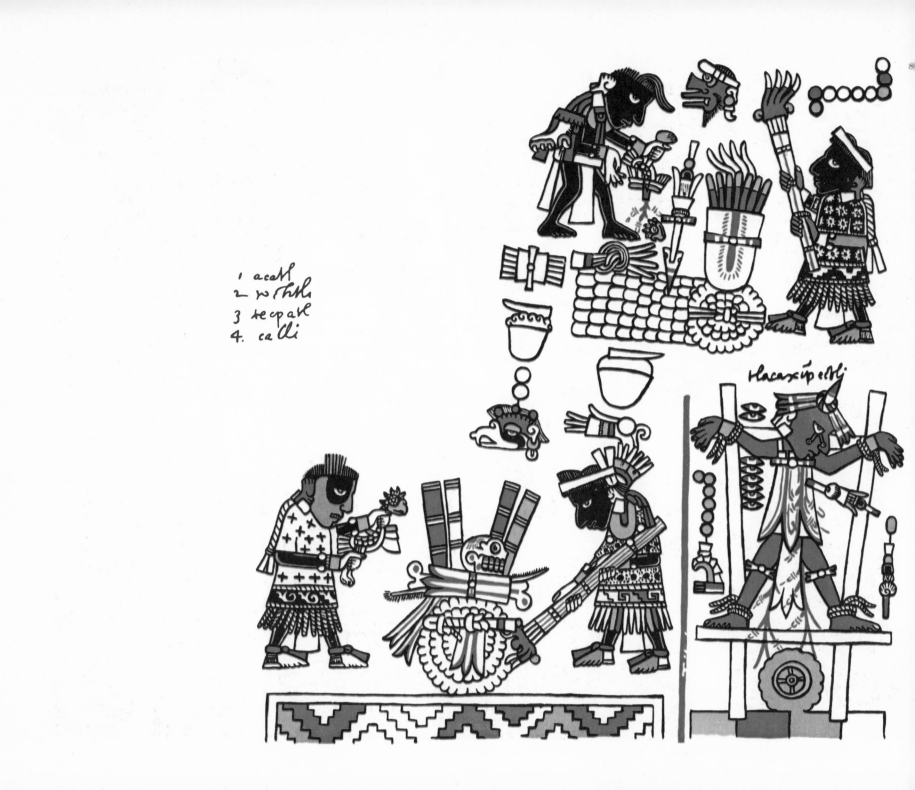

1 acatl
2 tochtli
3 tecpatl
4. calli

Tlacaxipeoli

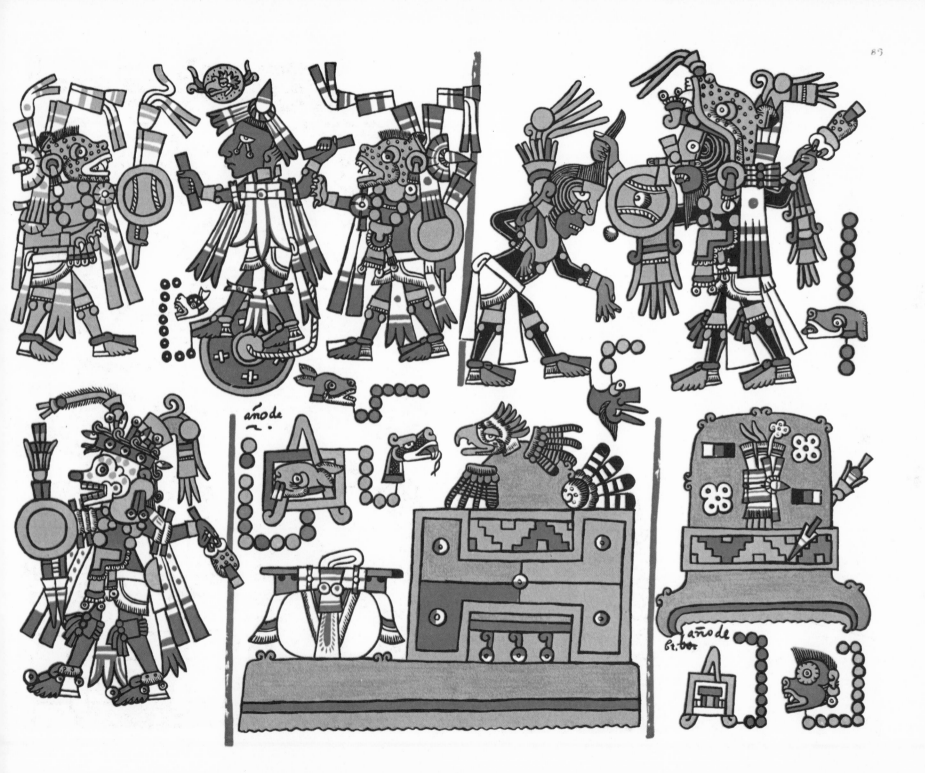

año de

año de

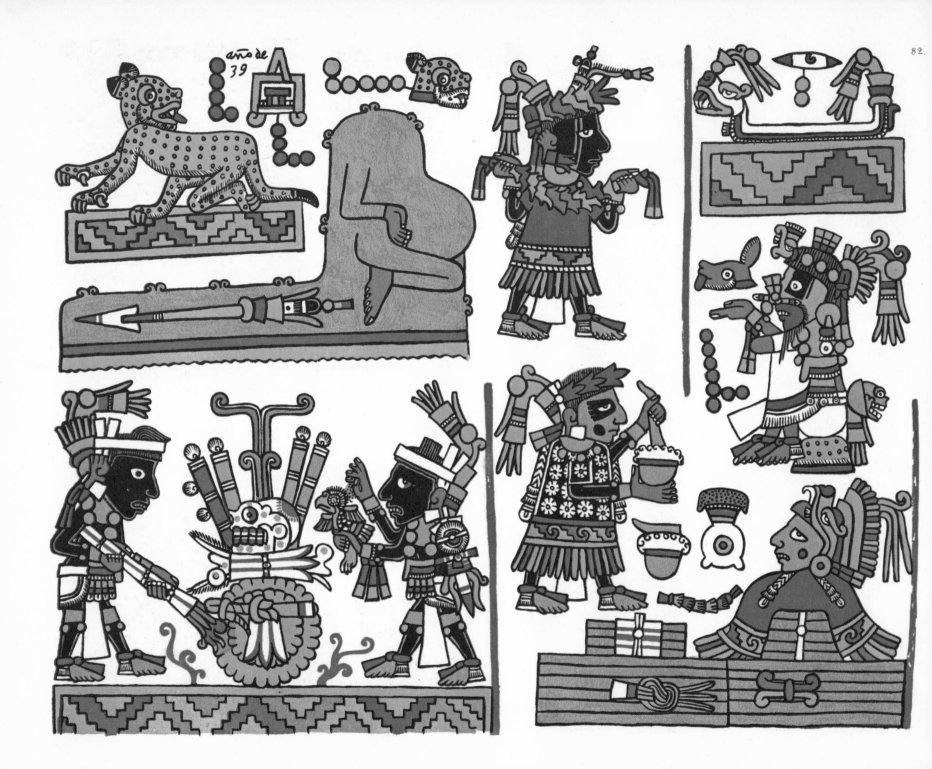

año de
39

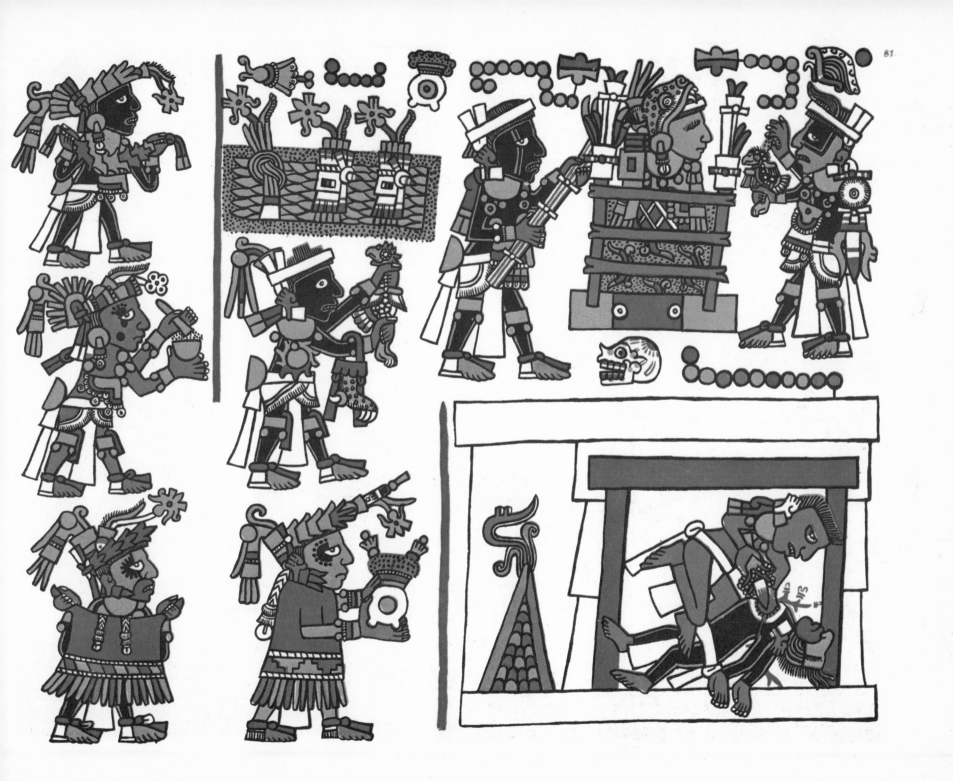

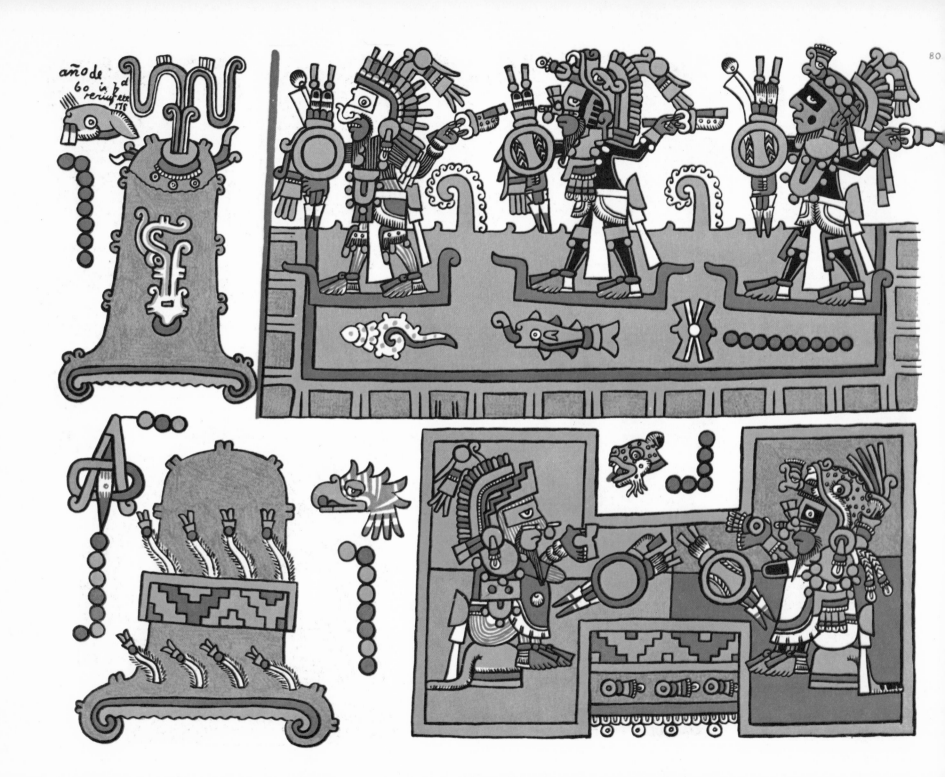

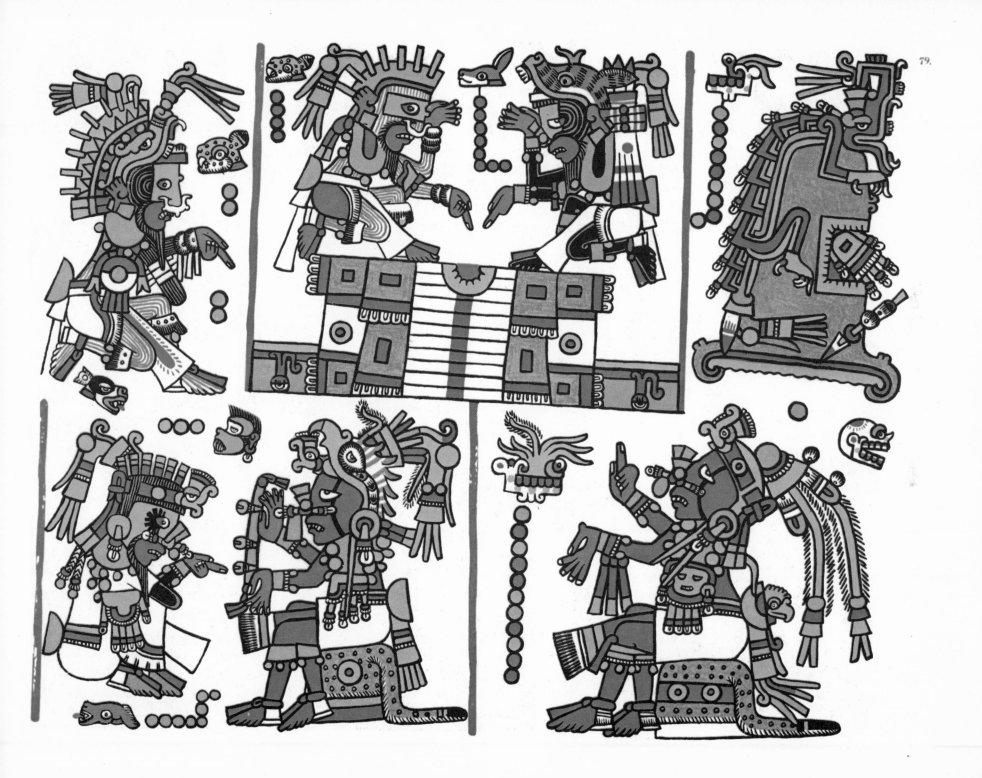

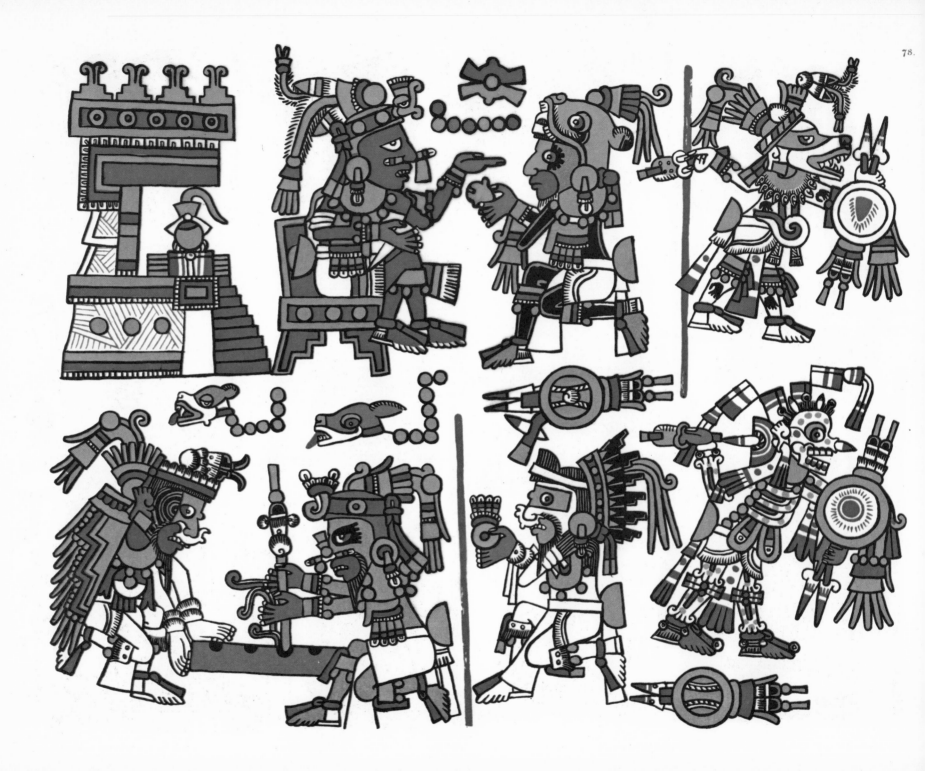

78.

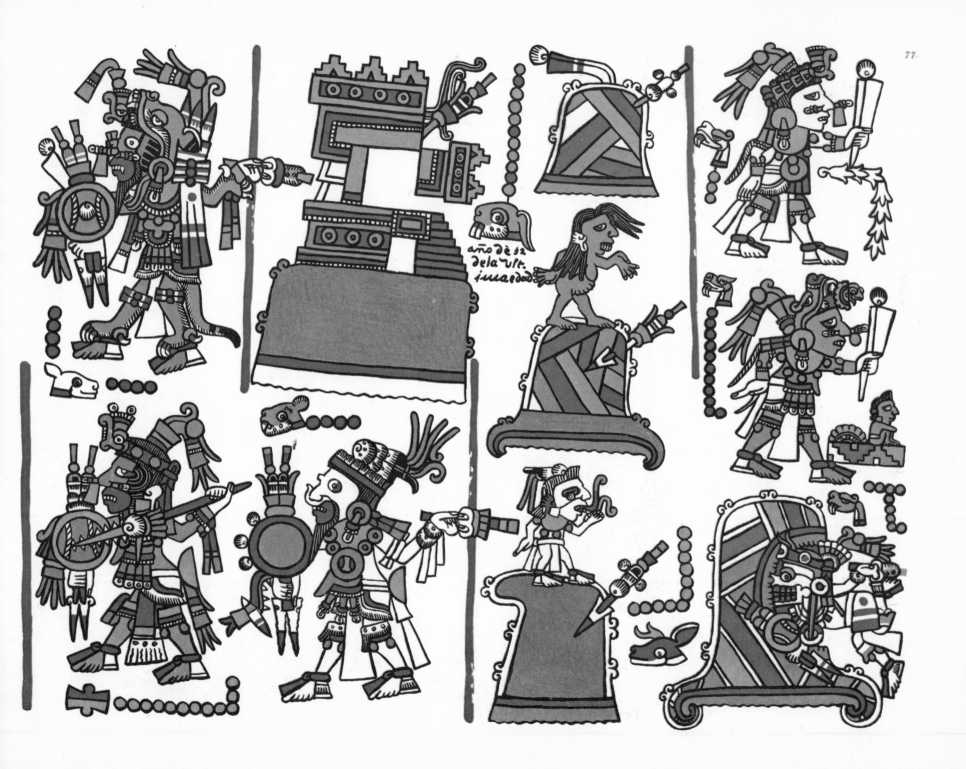

año de 12
dela vlt.
imadad

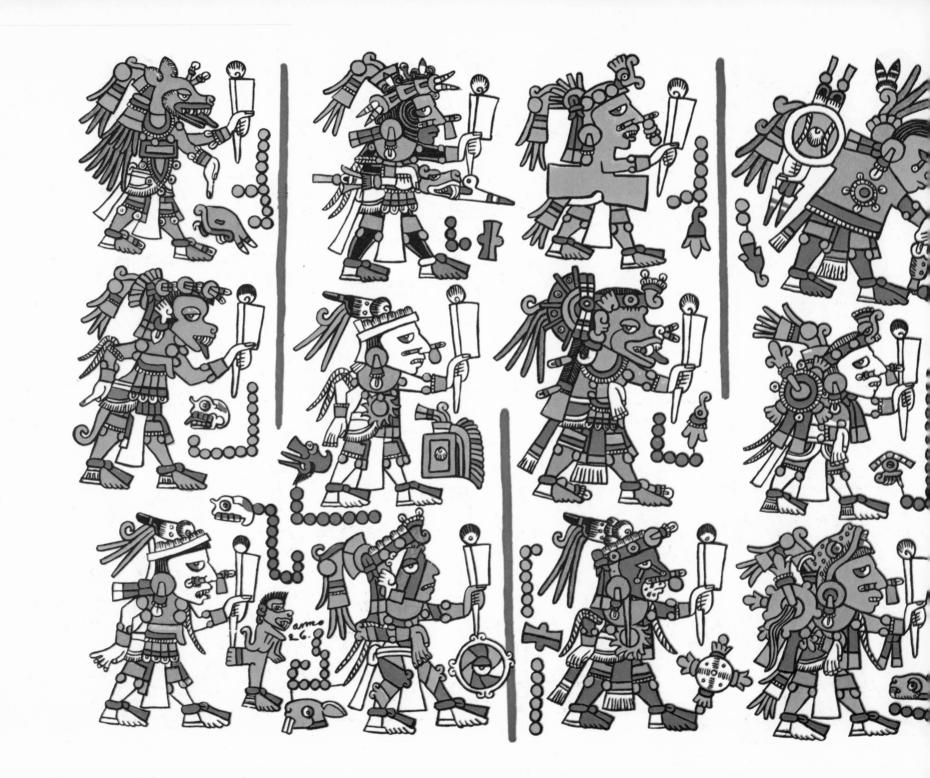

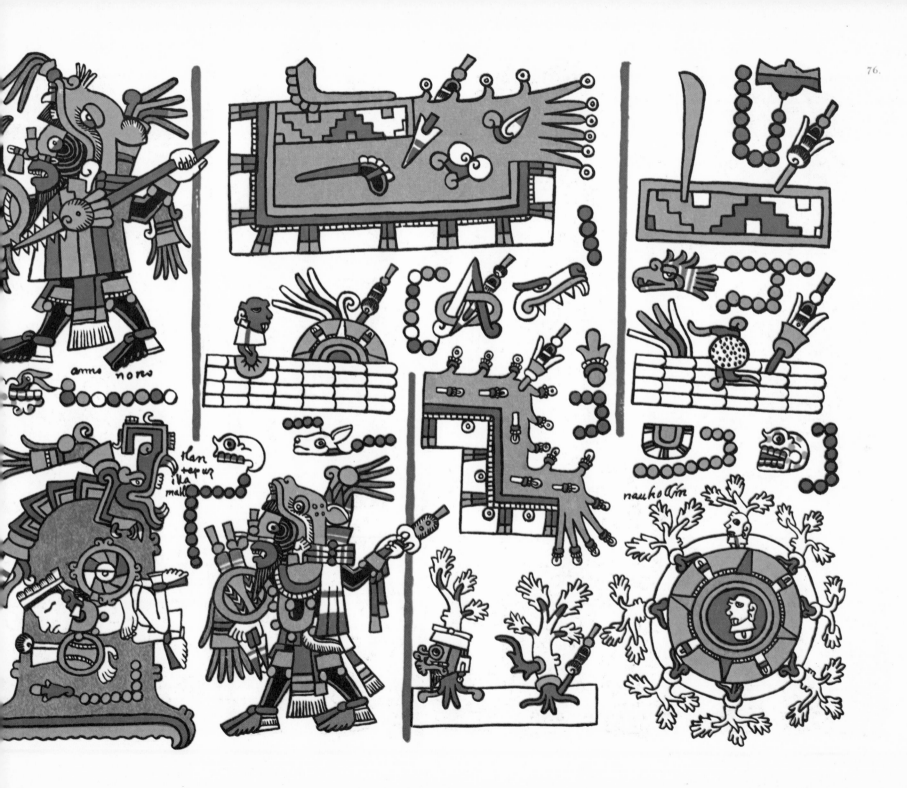

anmo nore

tlan
tepur
illa
mall

nauholin

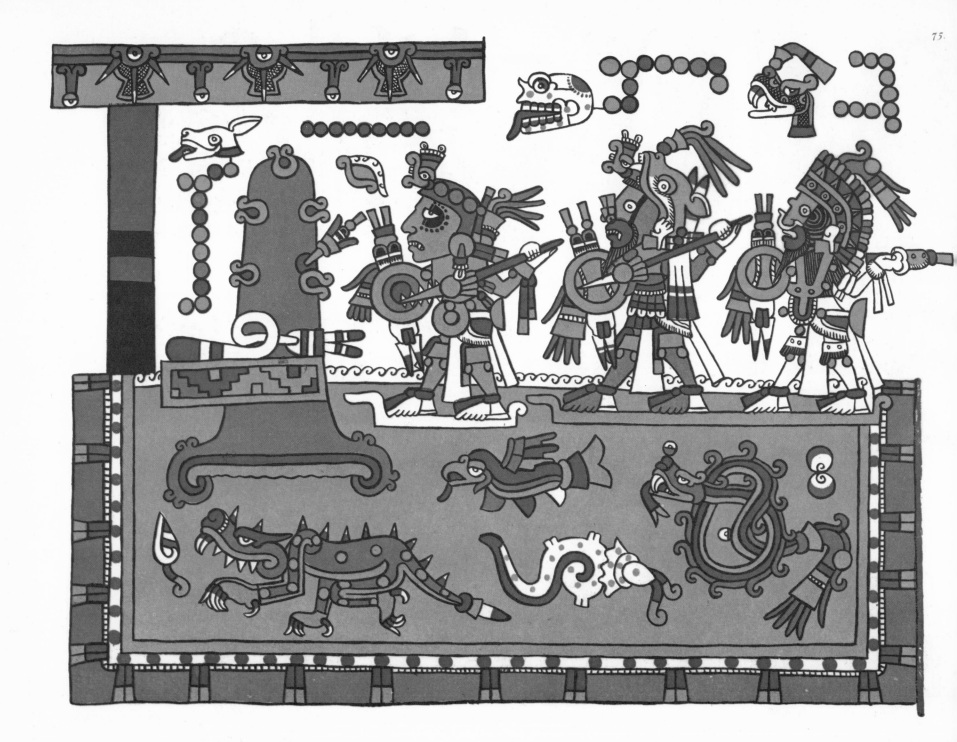

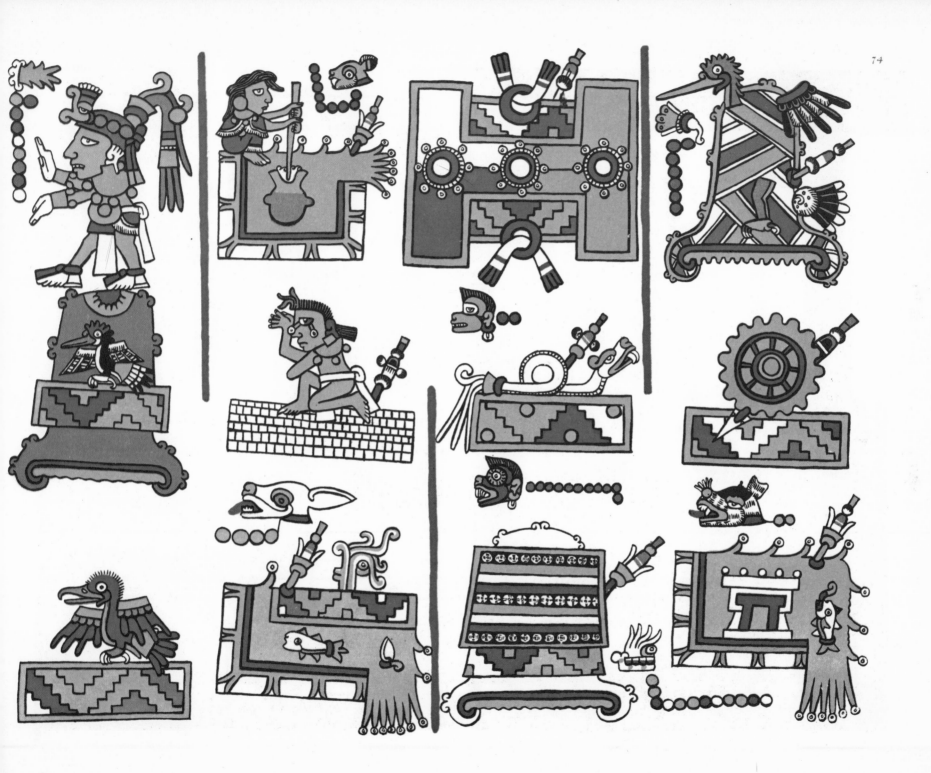

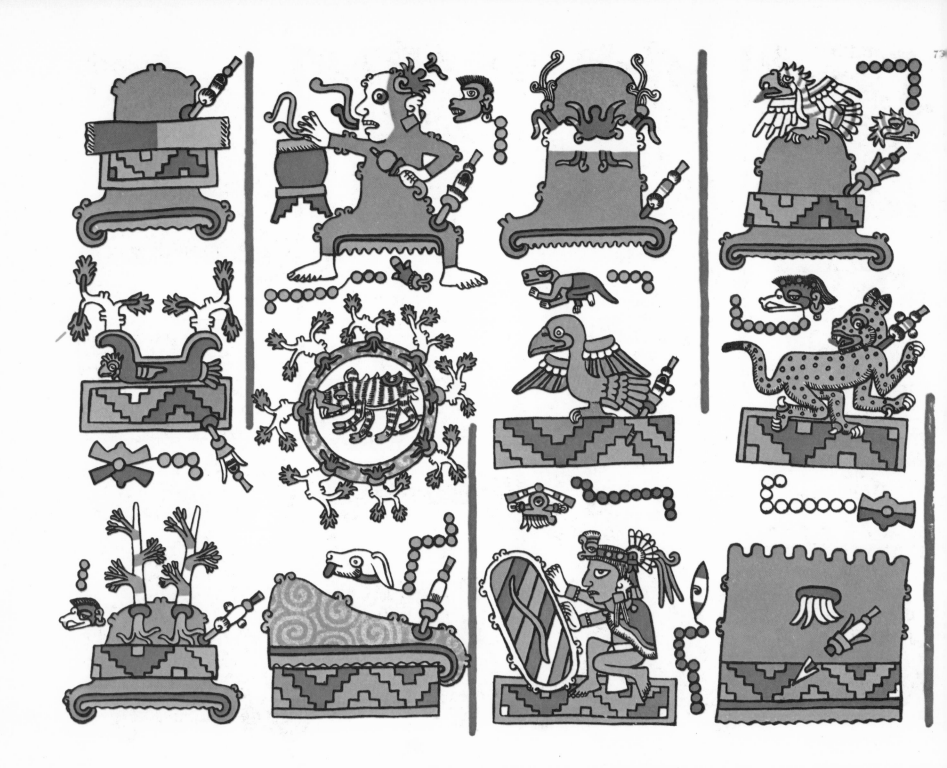

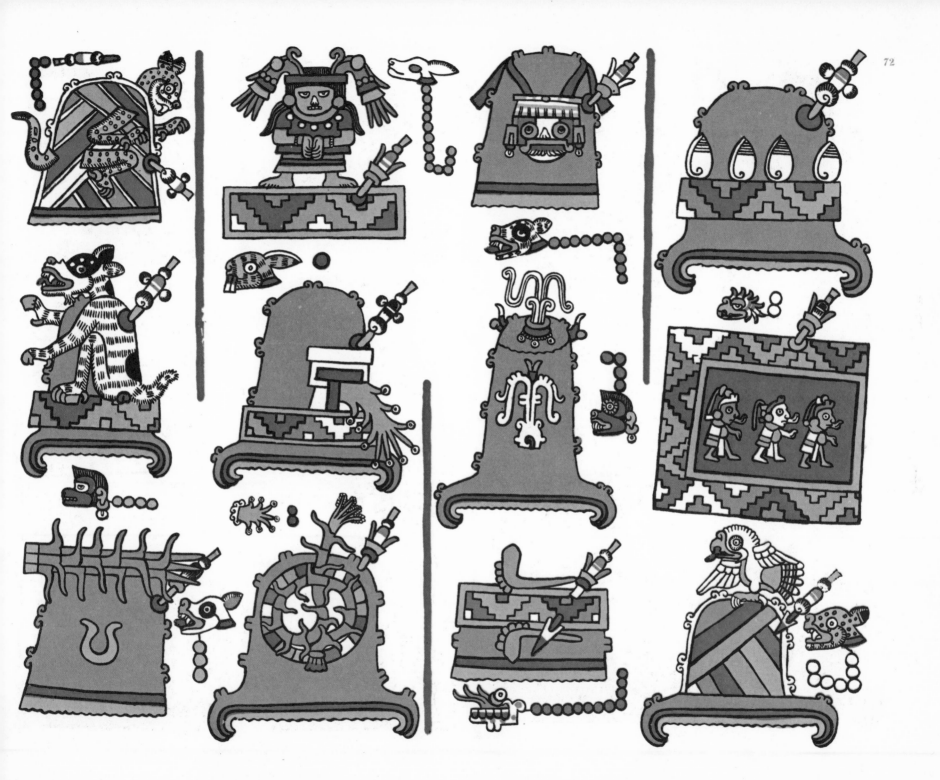

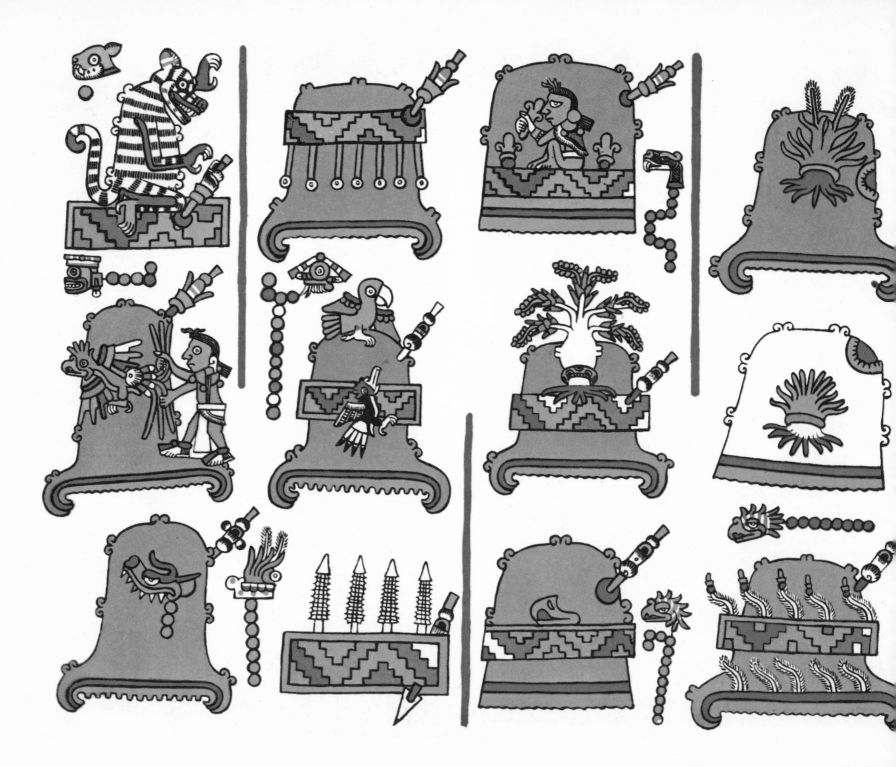

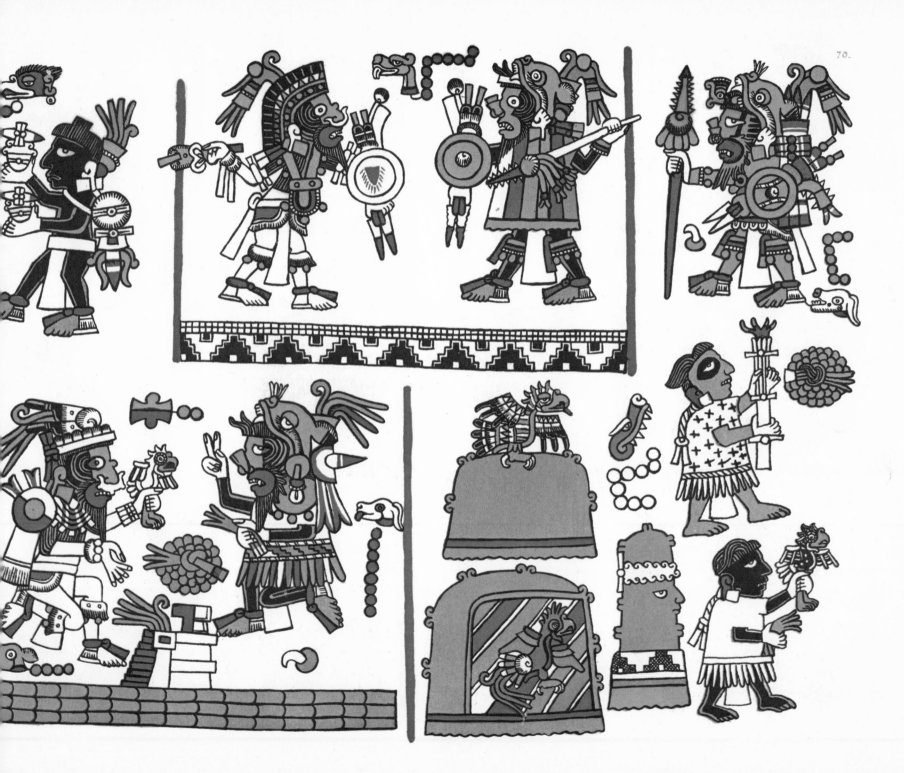

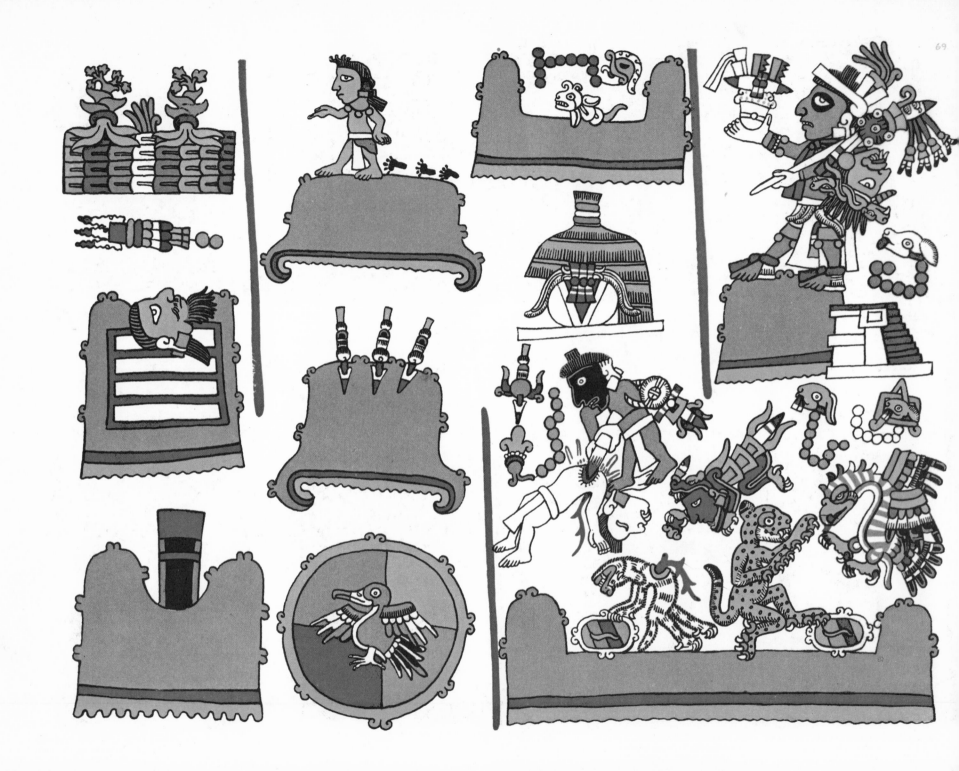

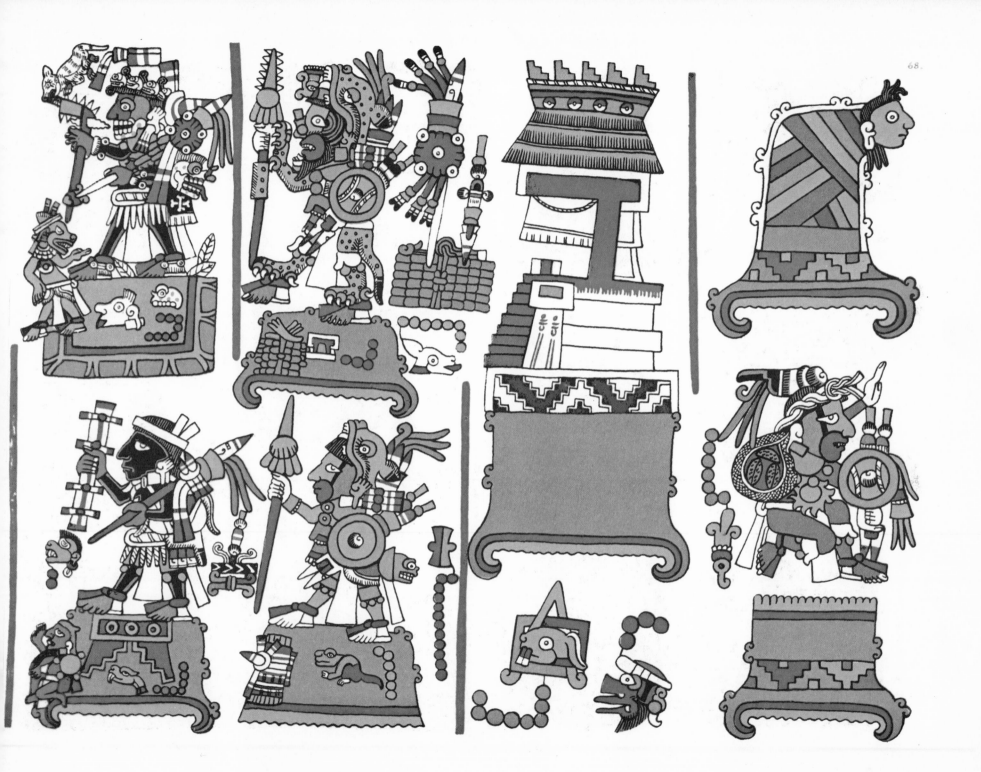

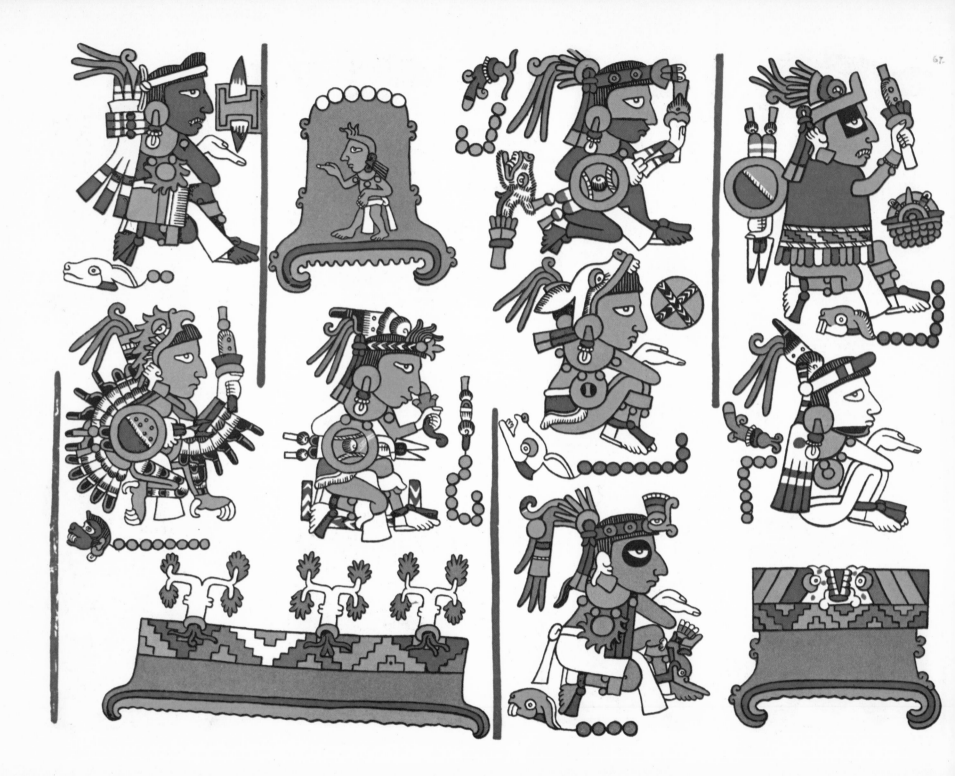

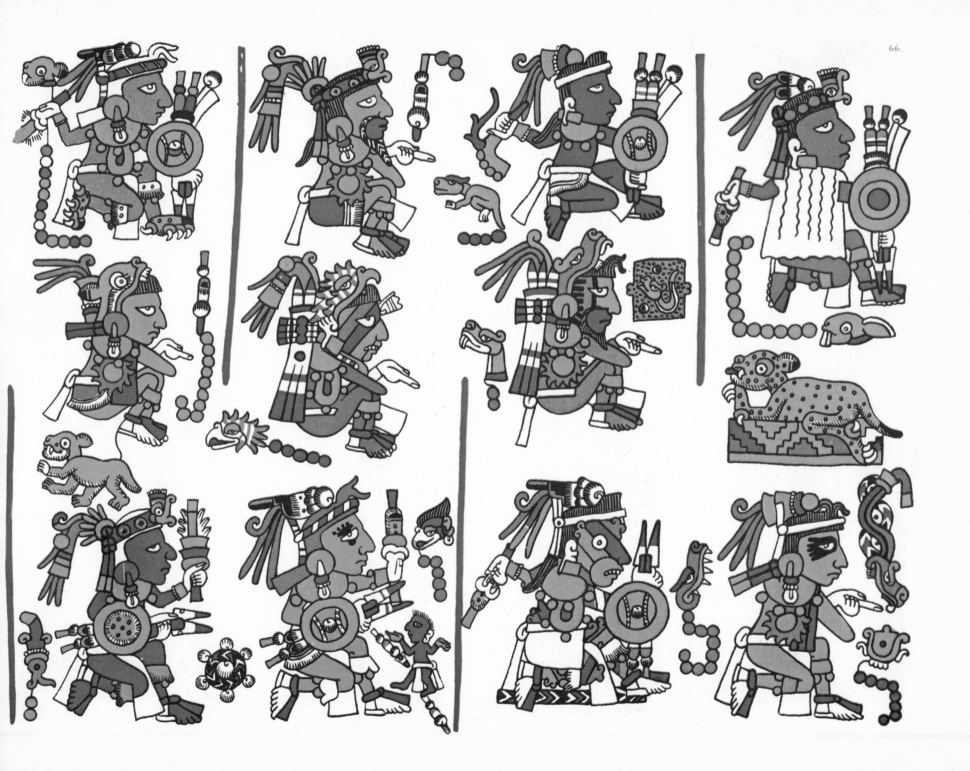

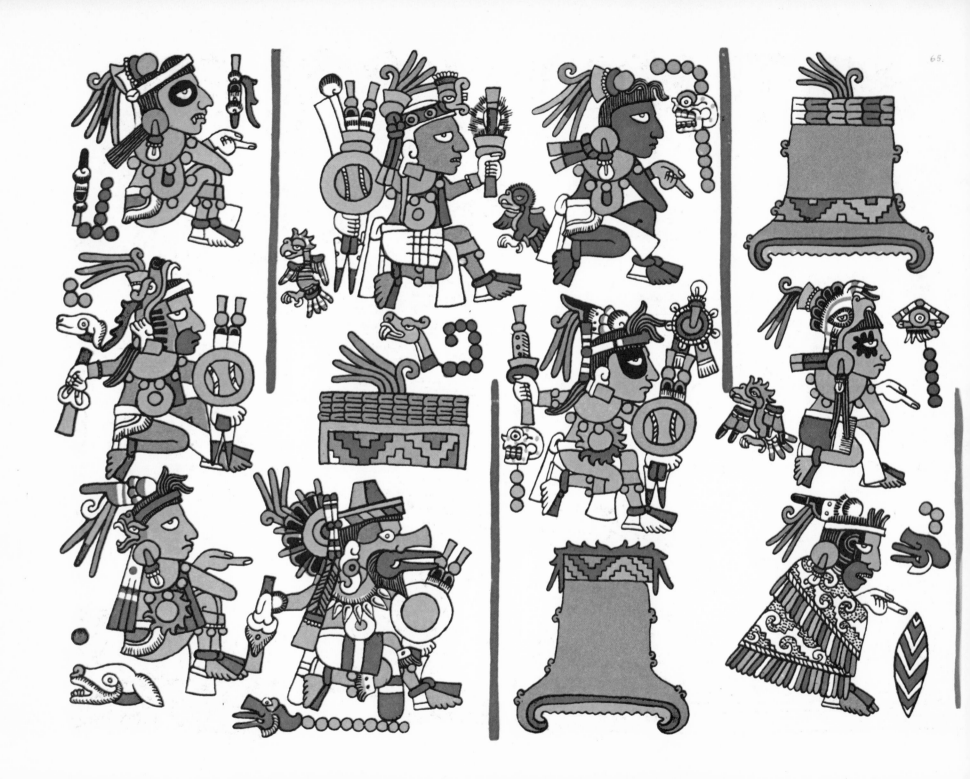

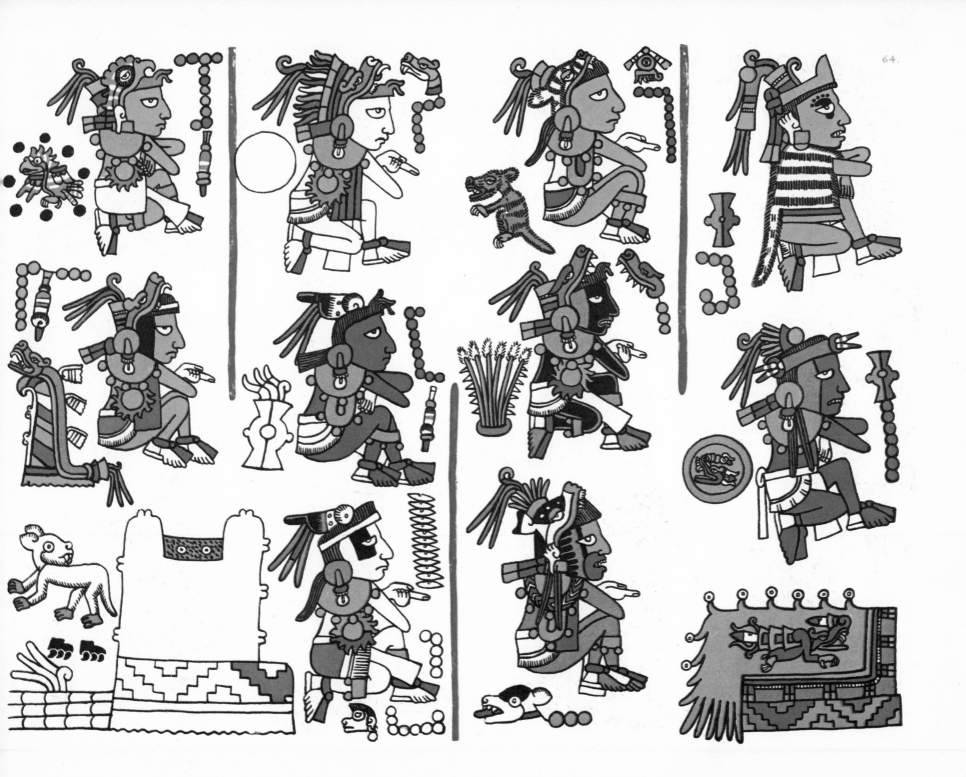

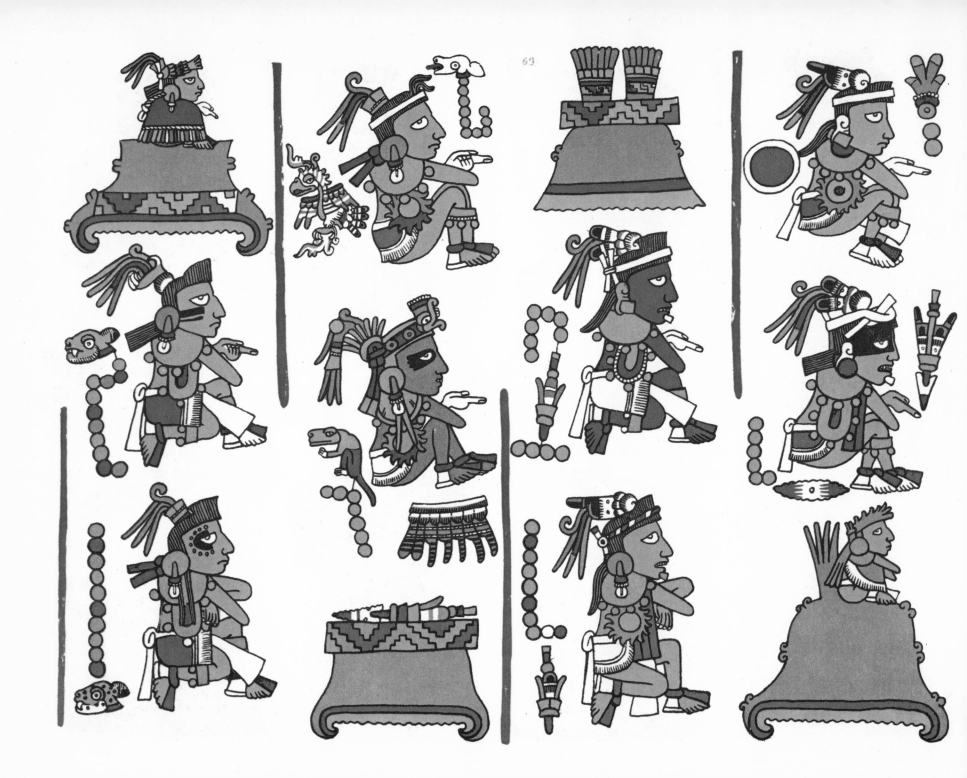

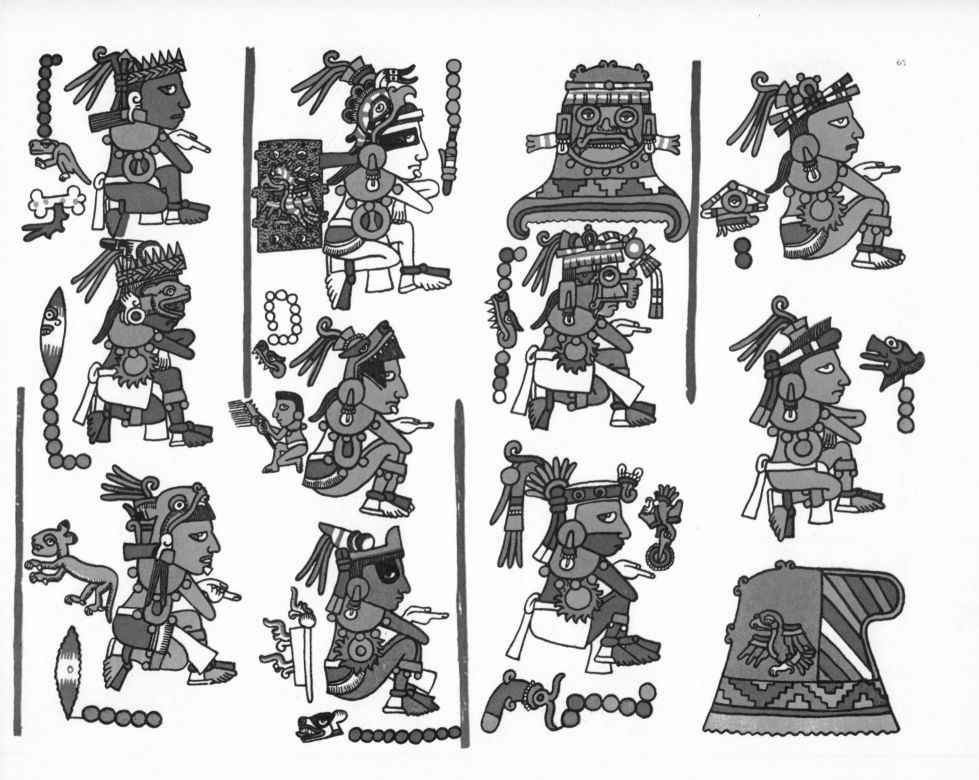

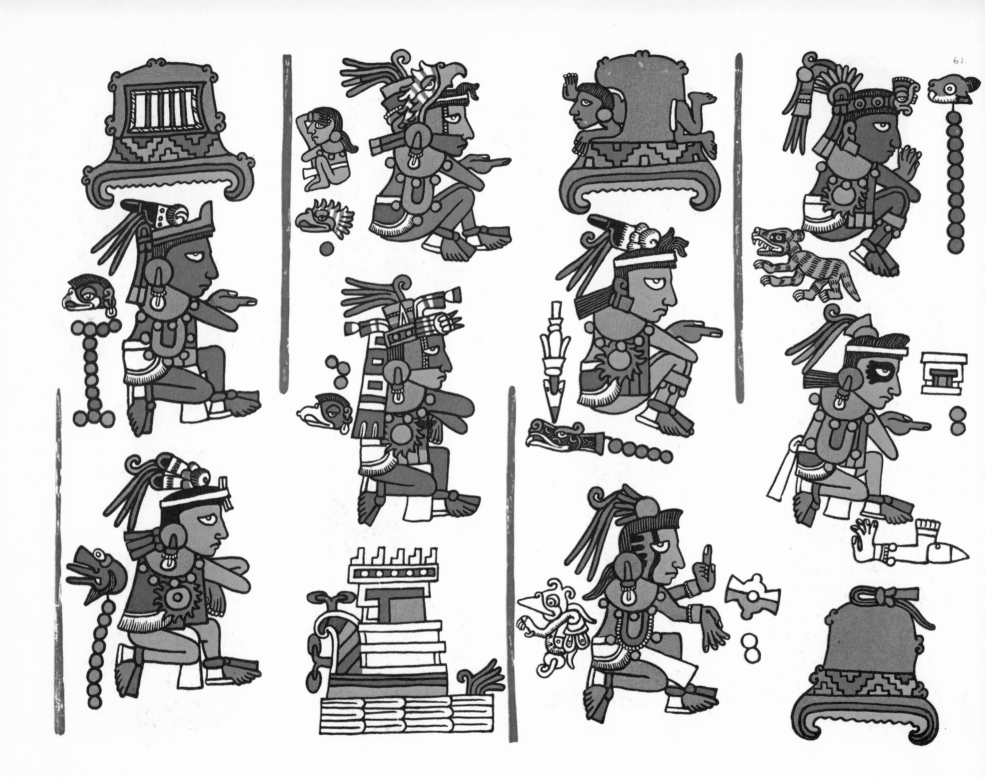

61.

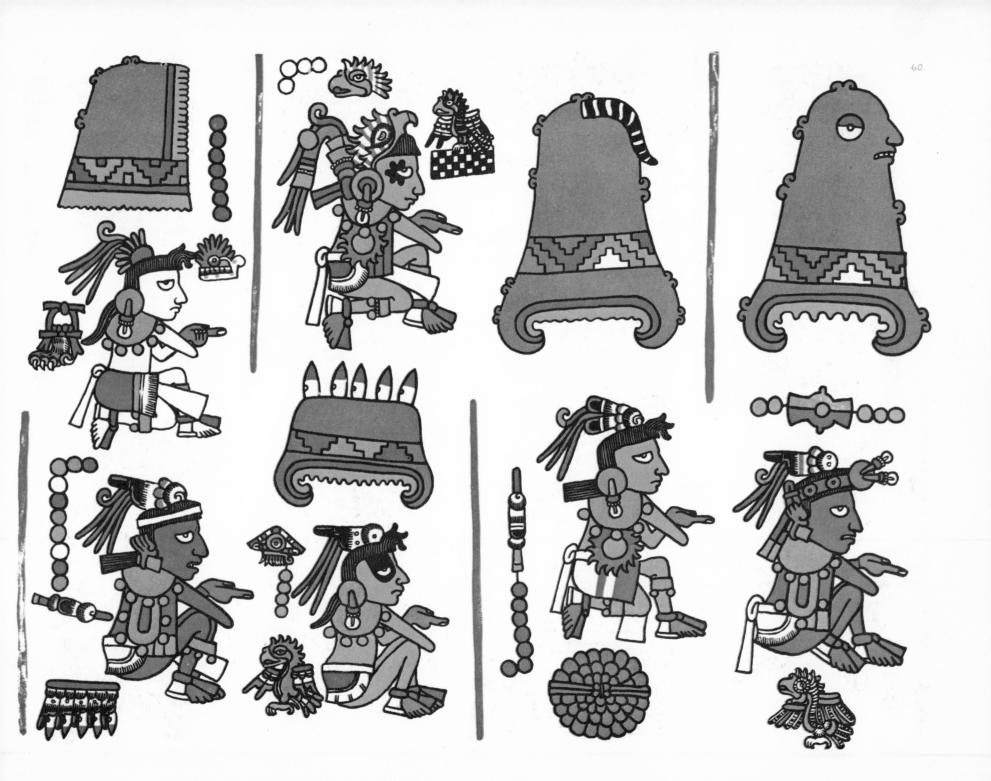

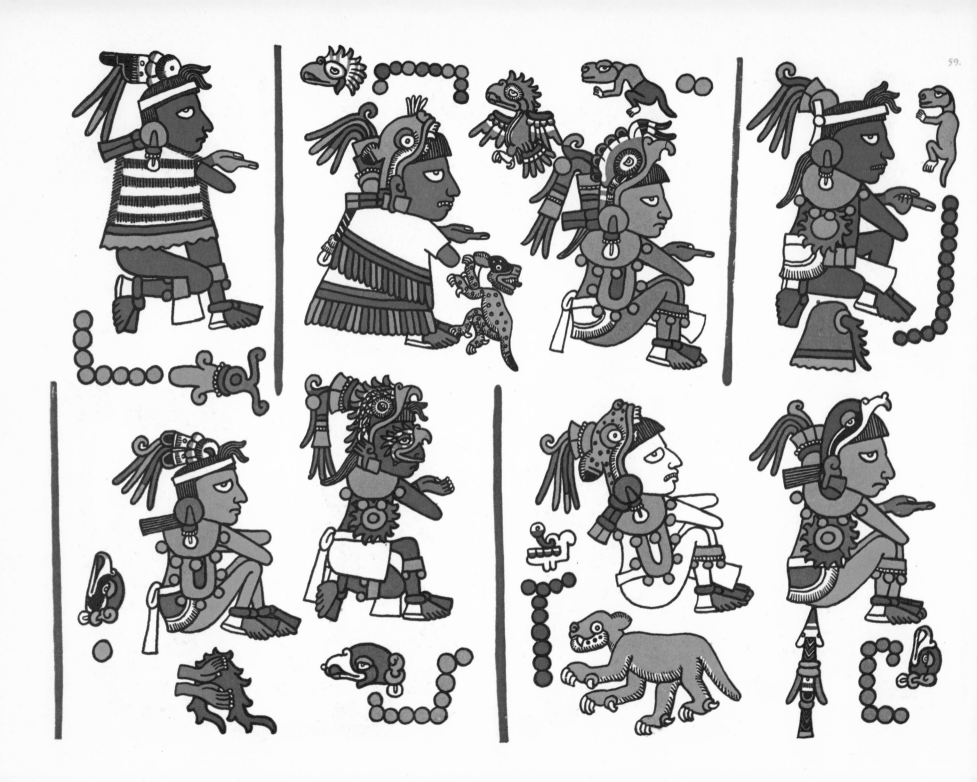

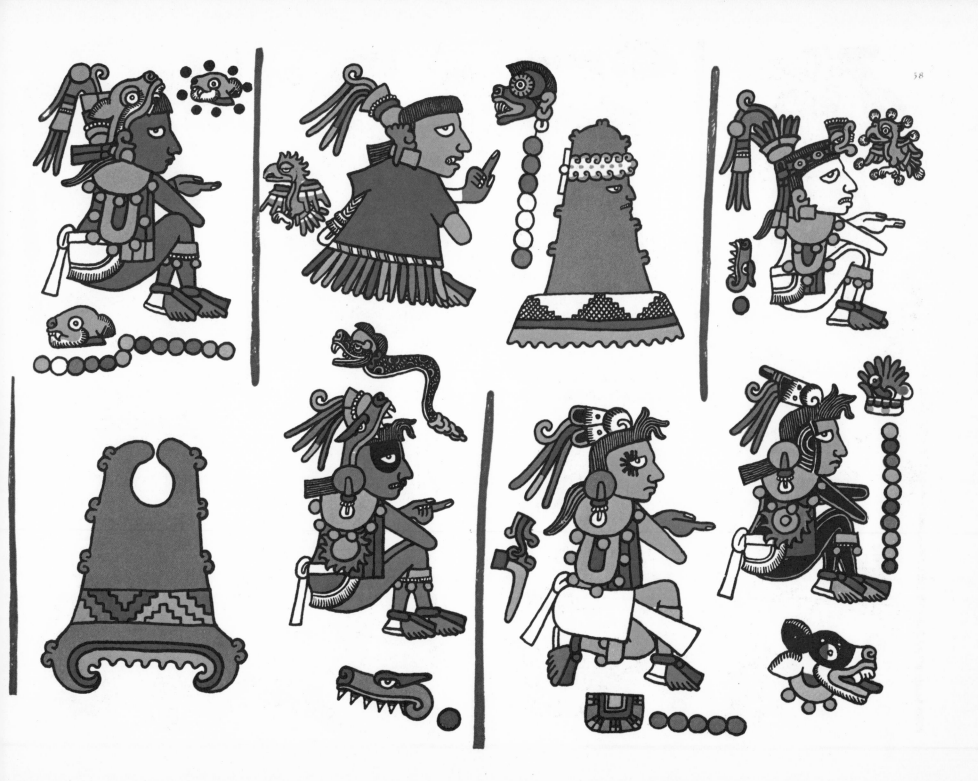

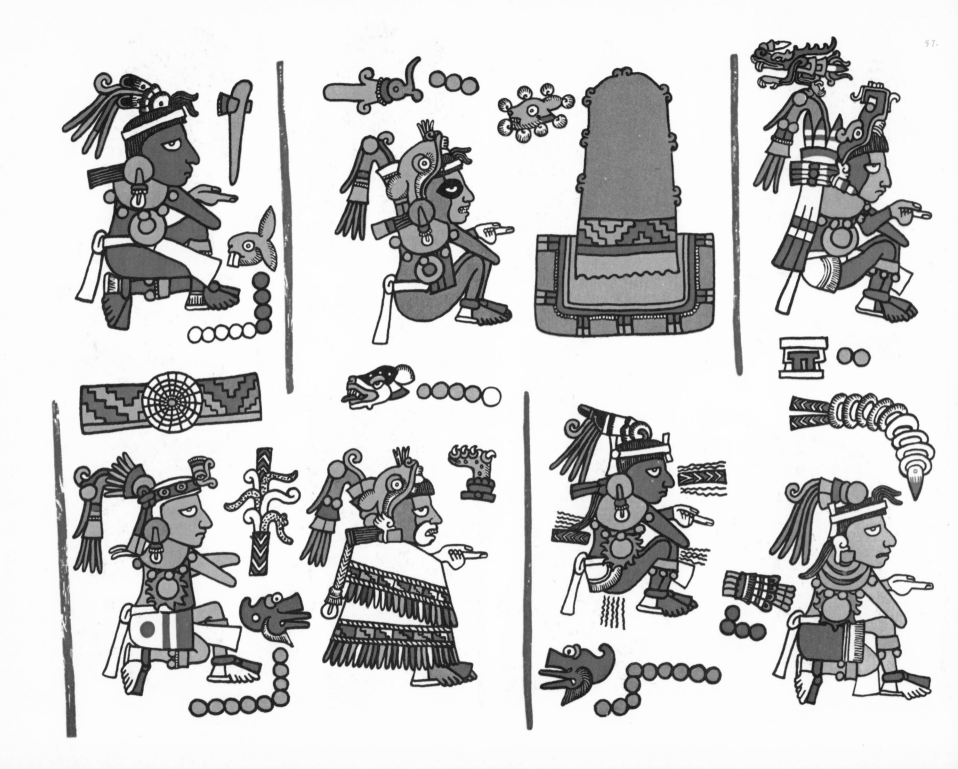

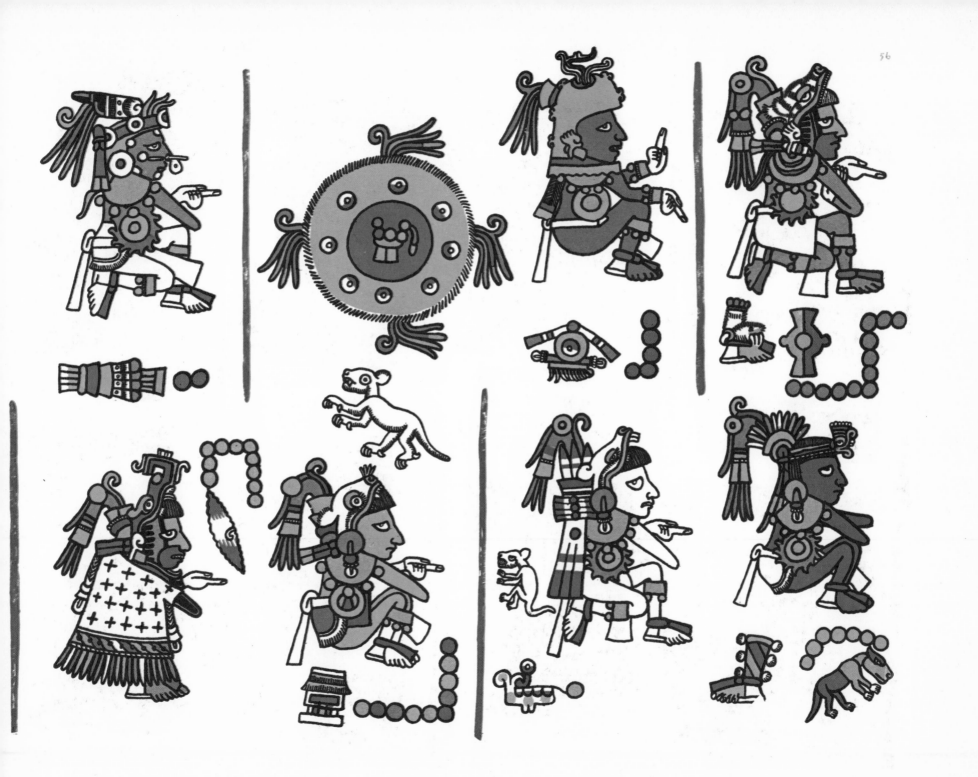

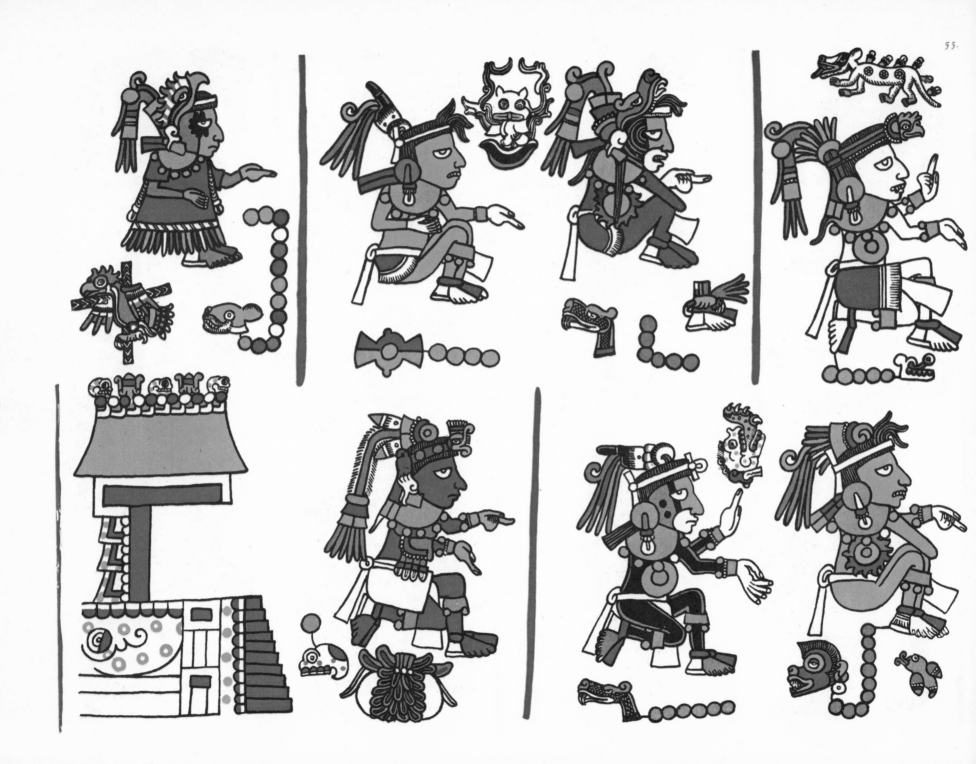

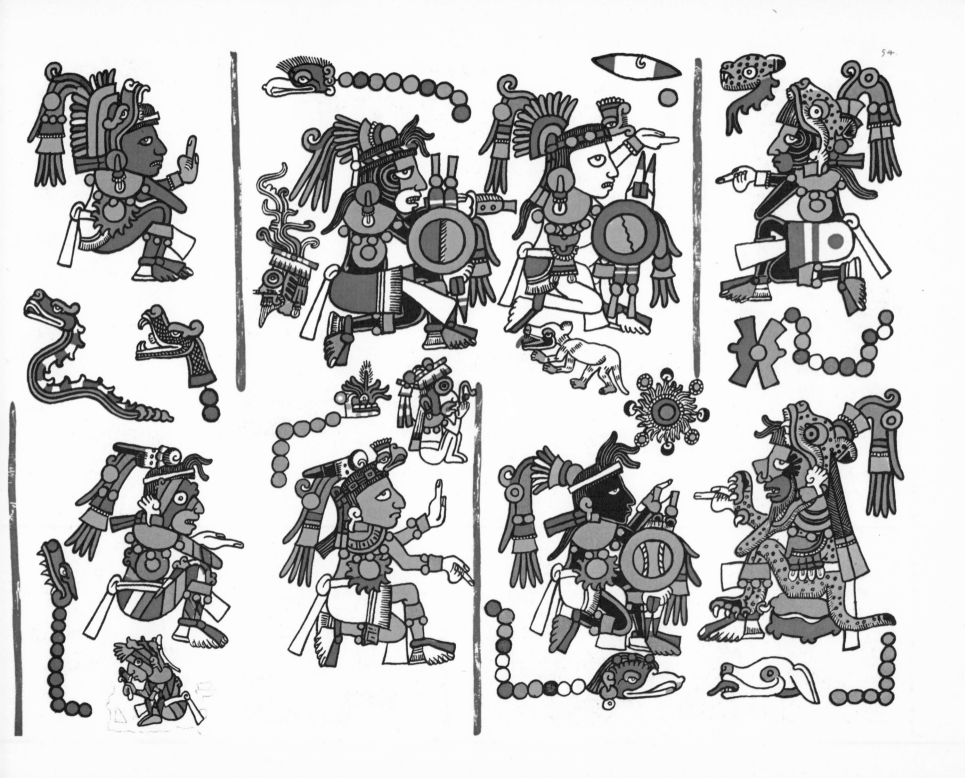

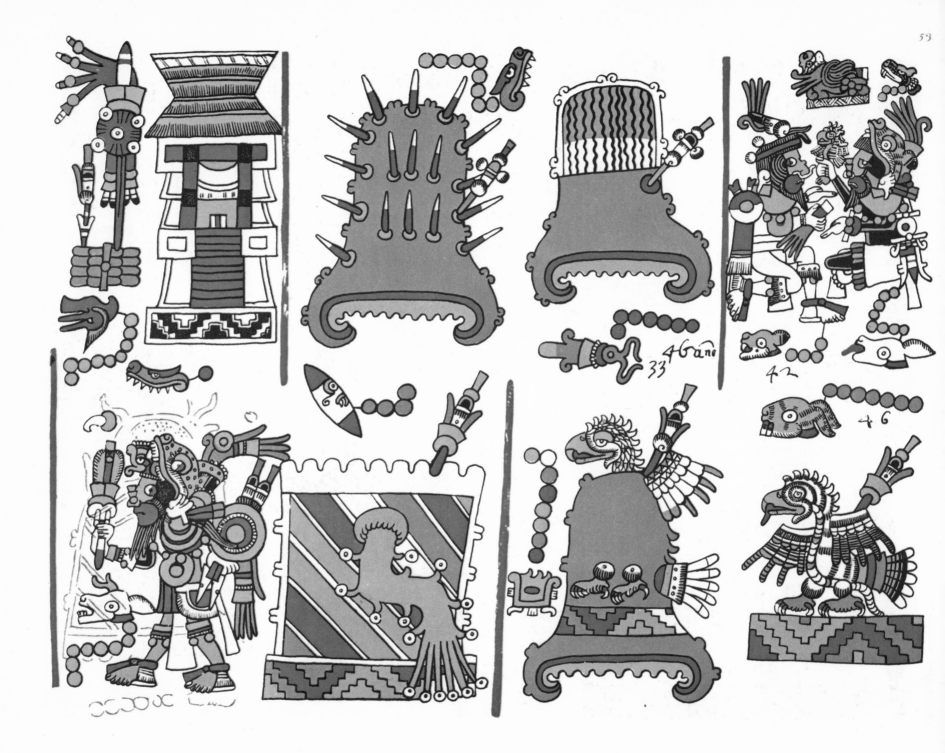

53

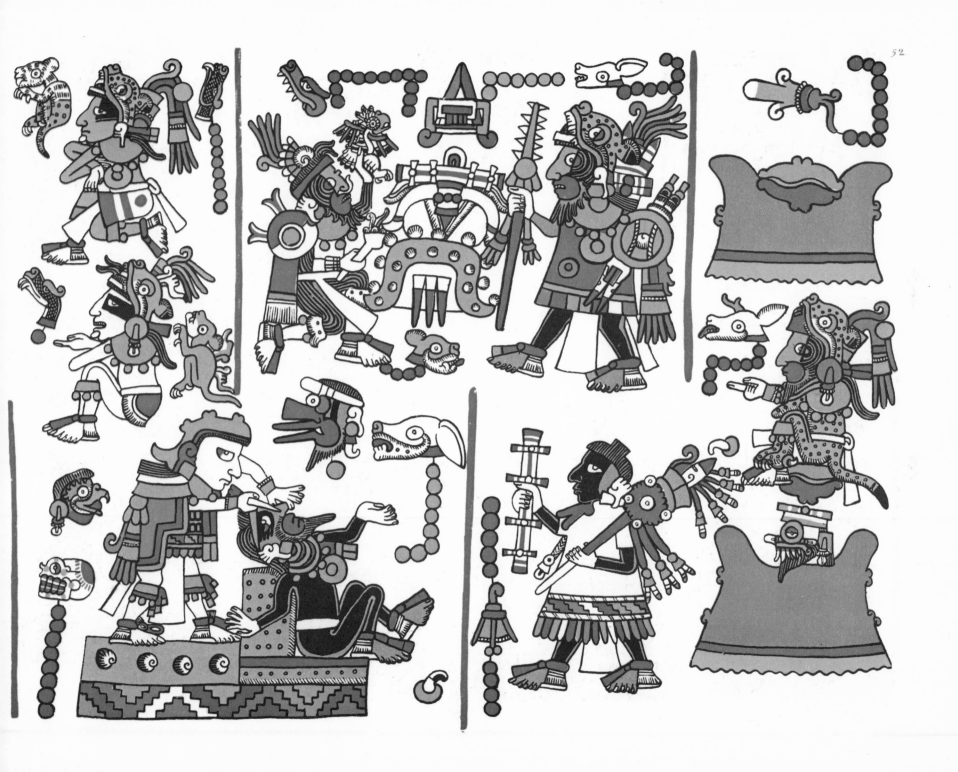

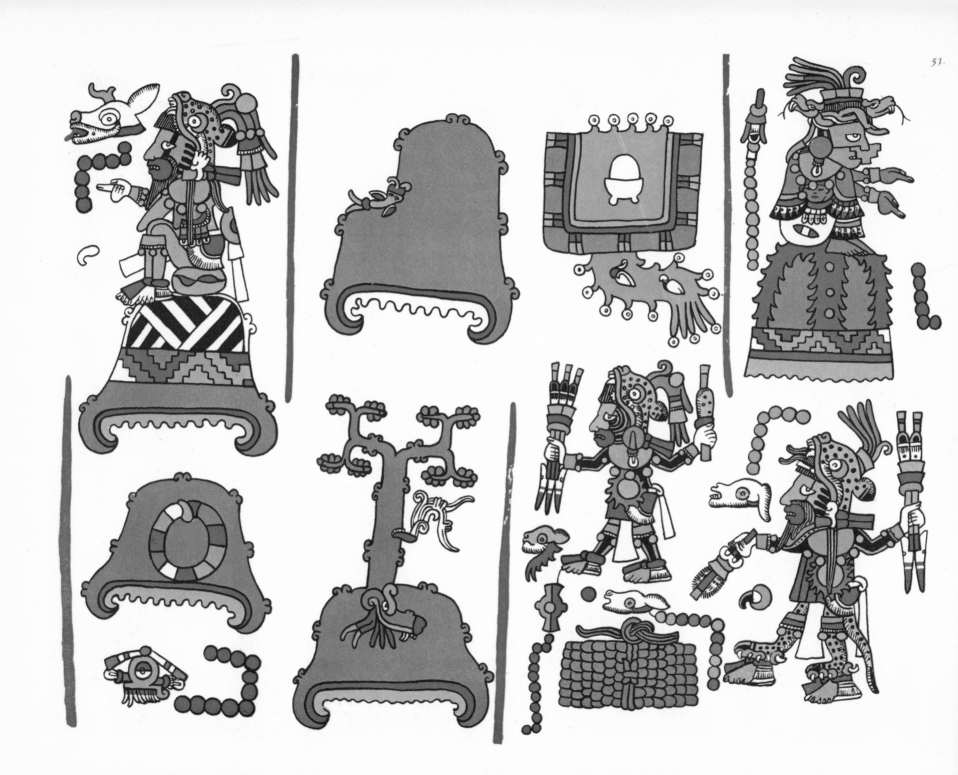

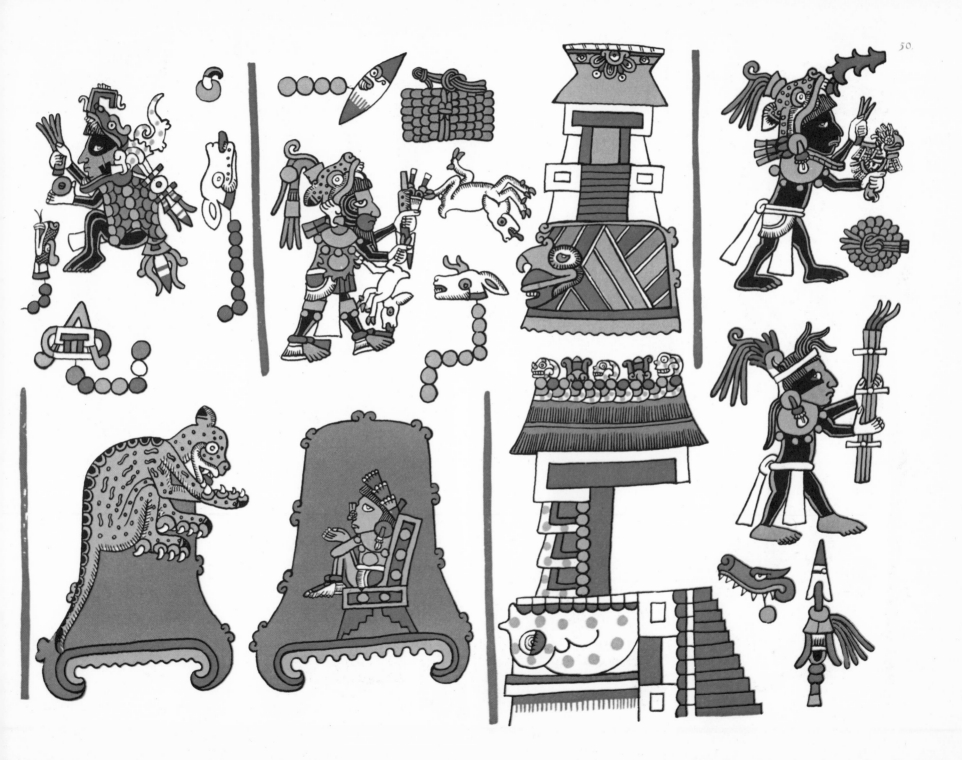

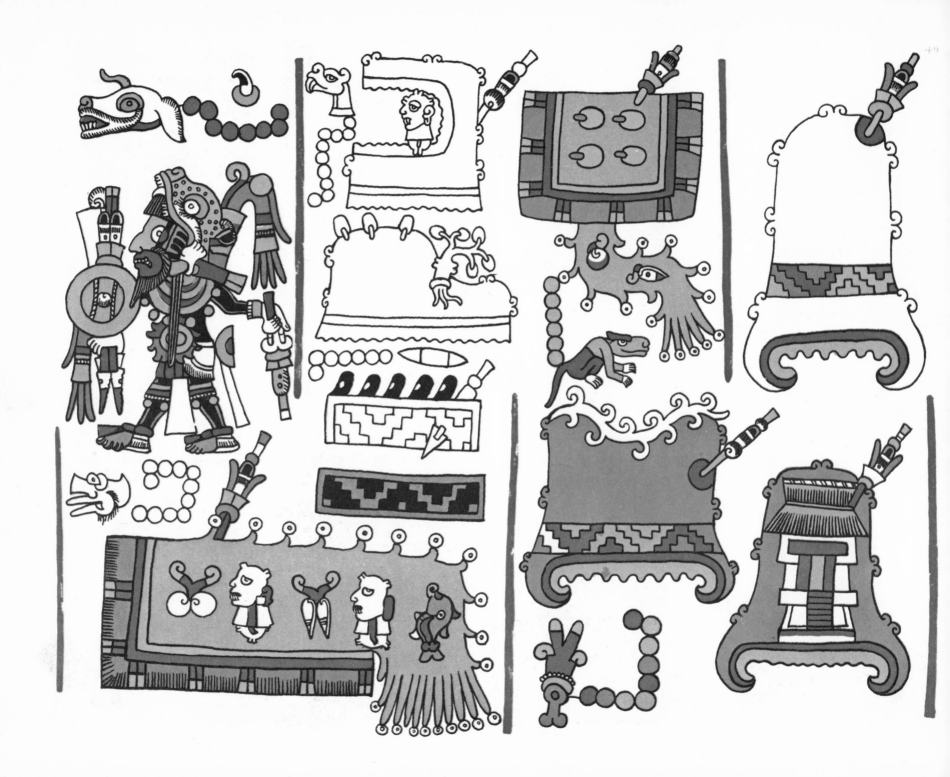

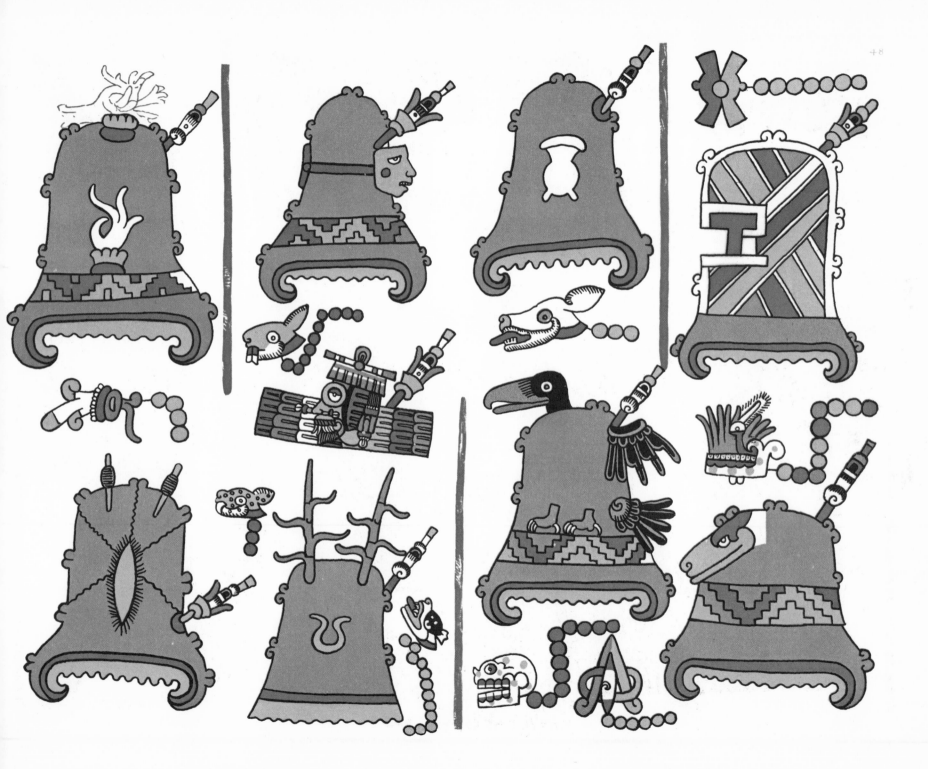

48

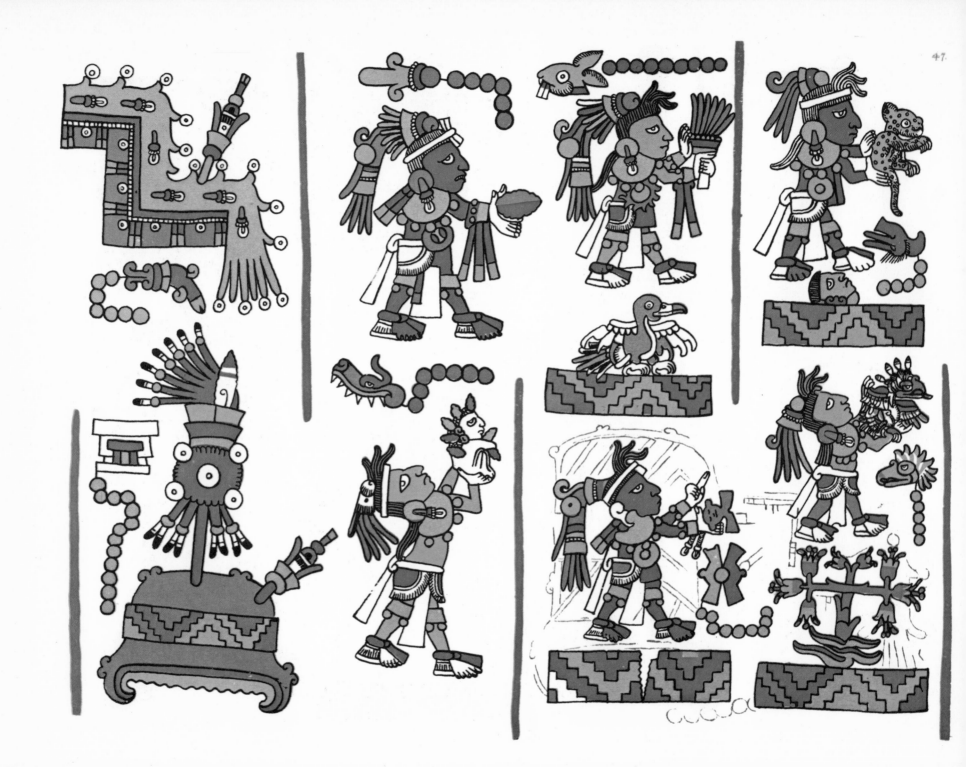

47.

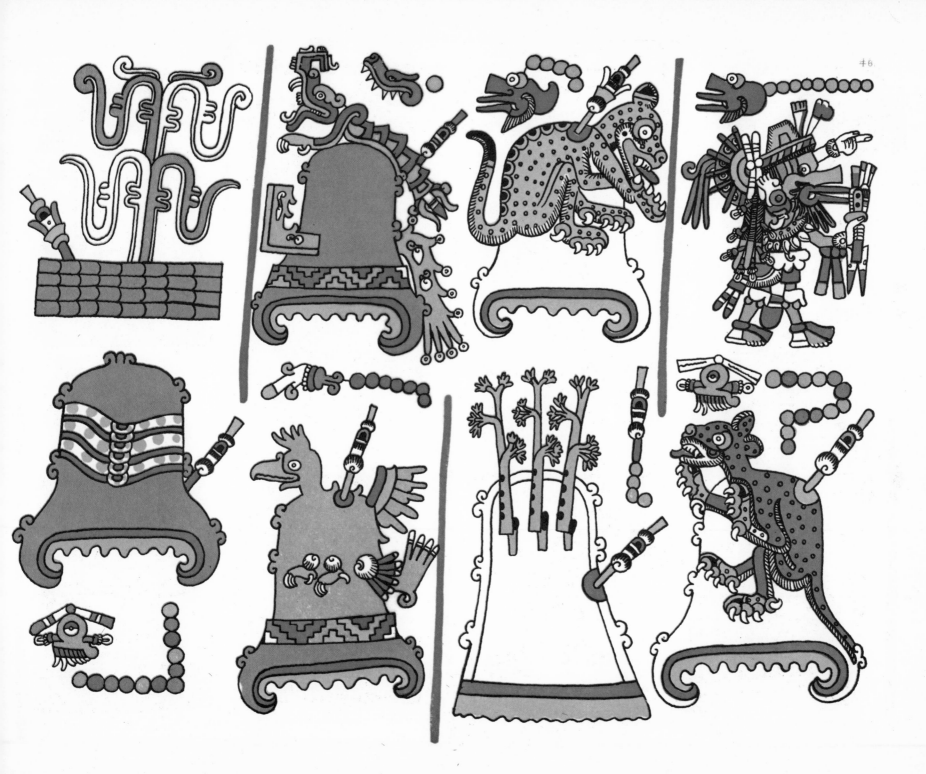

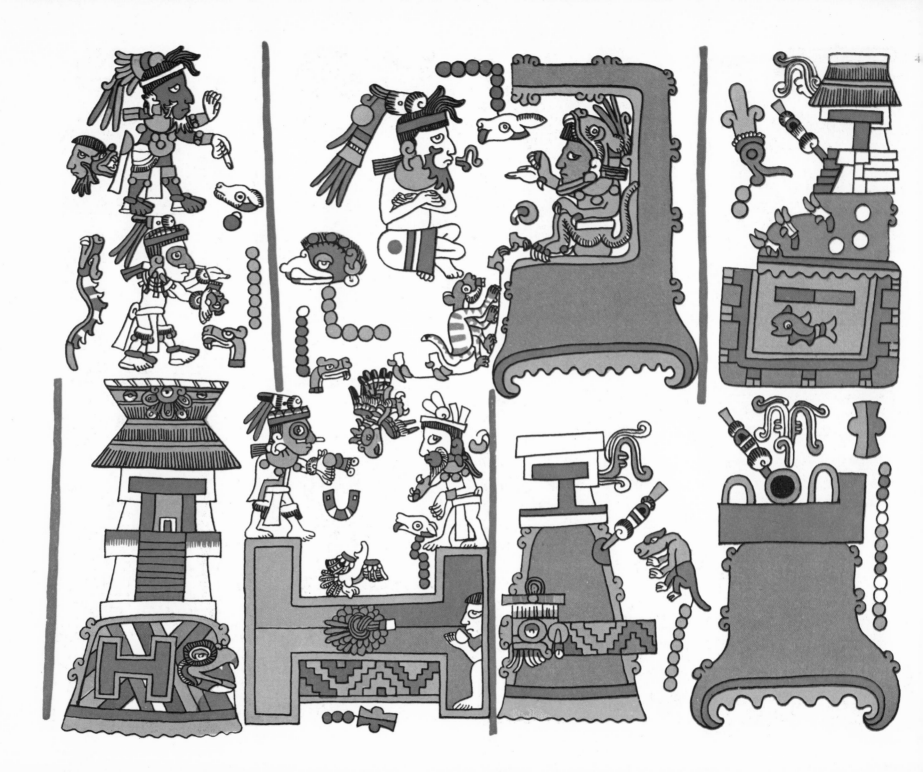

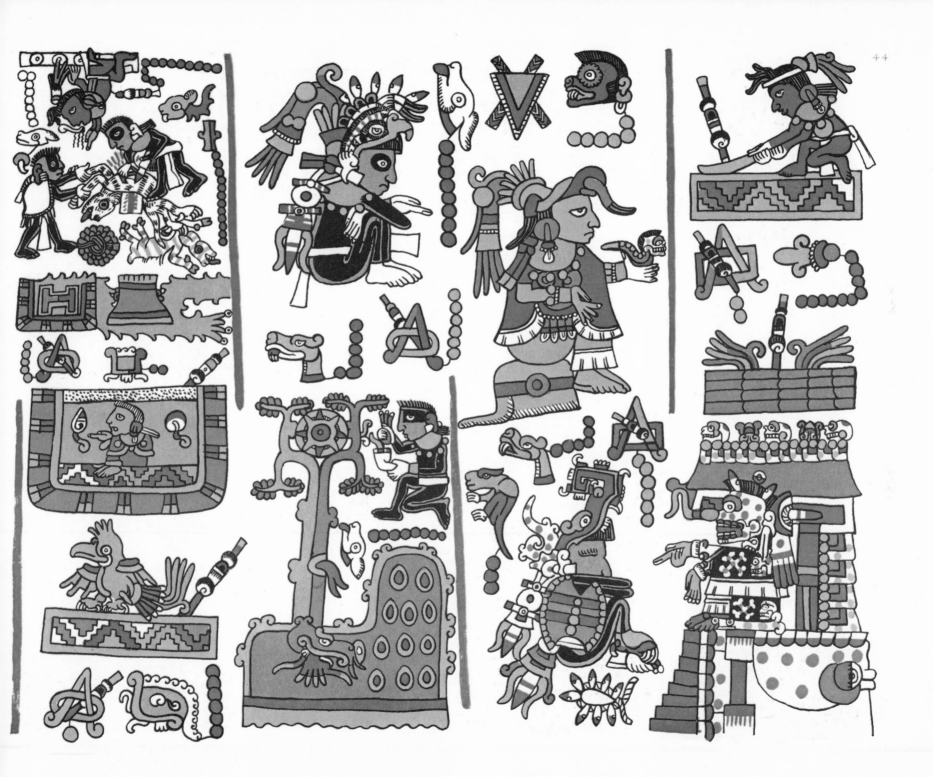

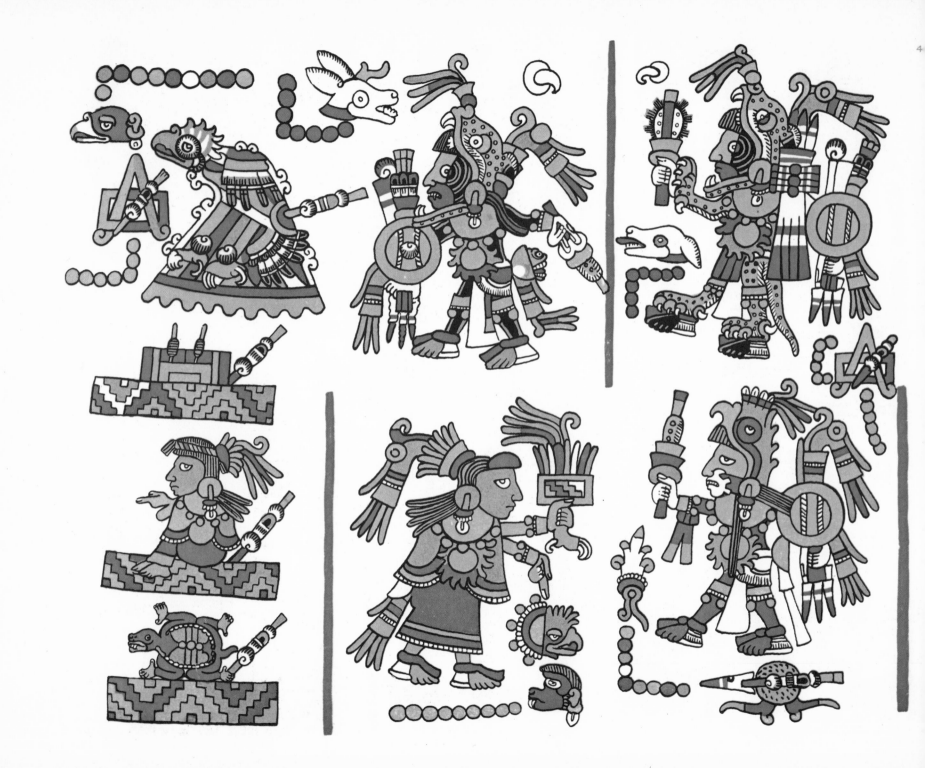

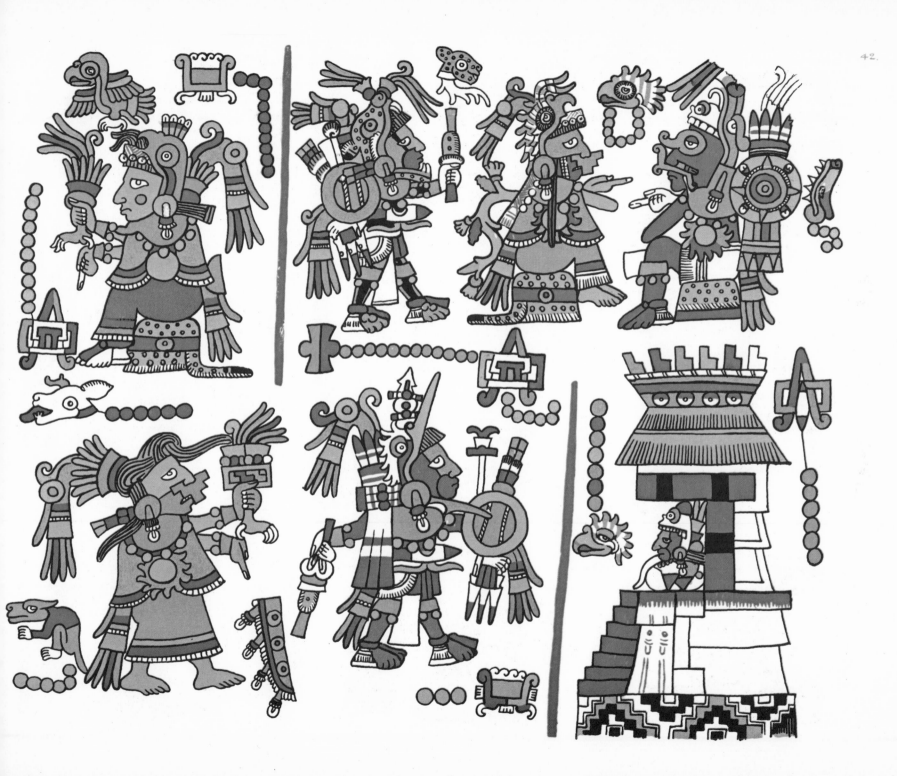

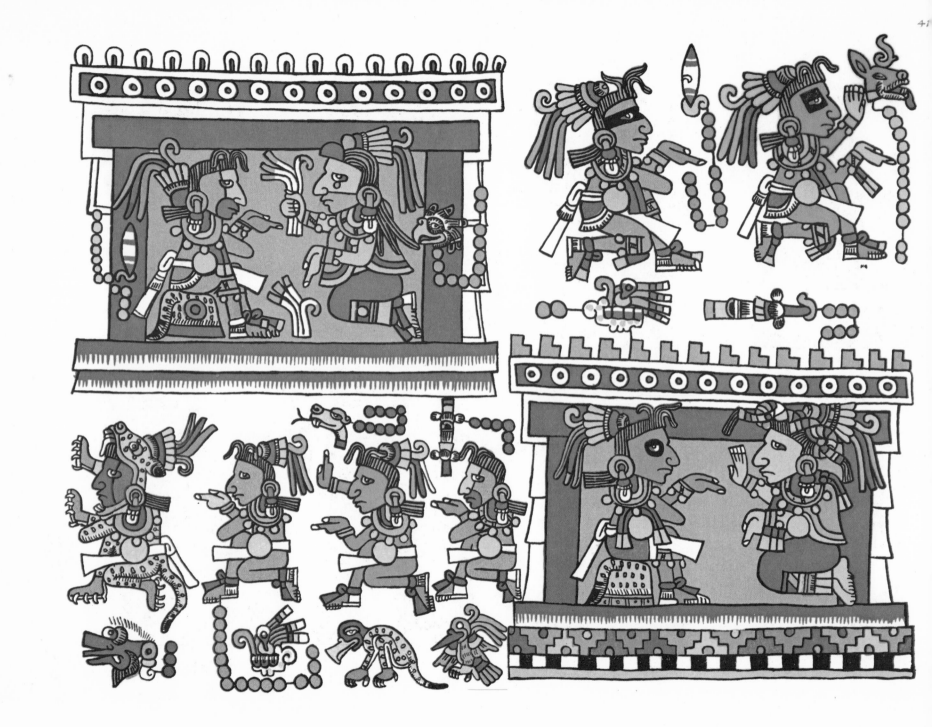

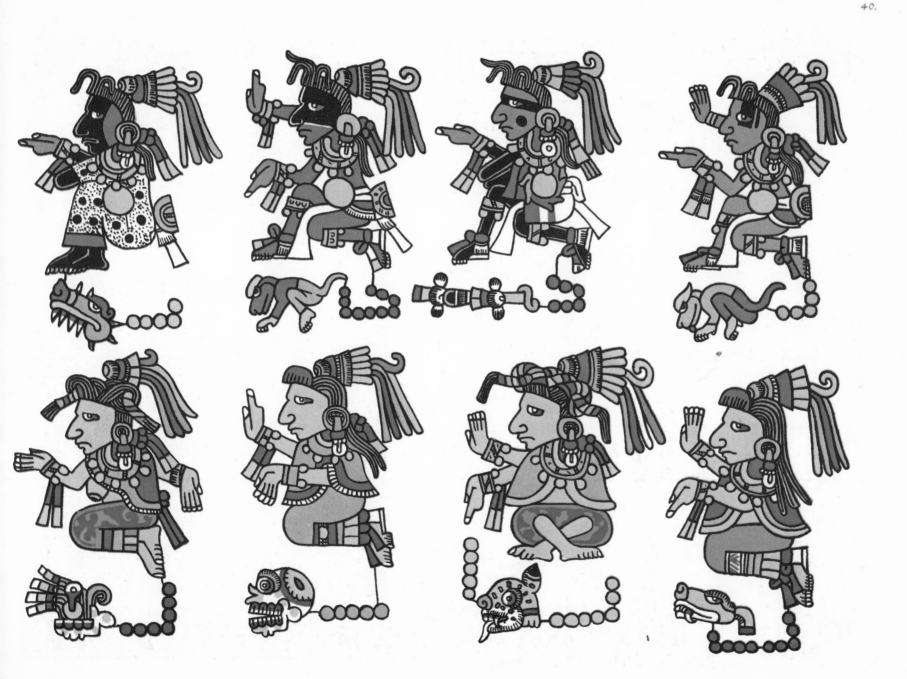

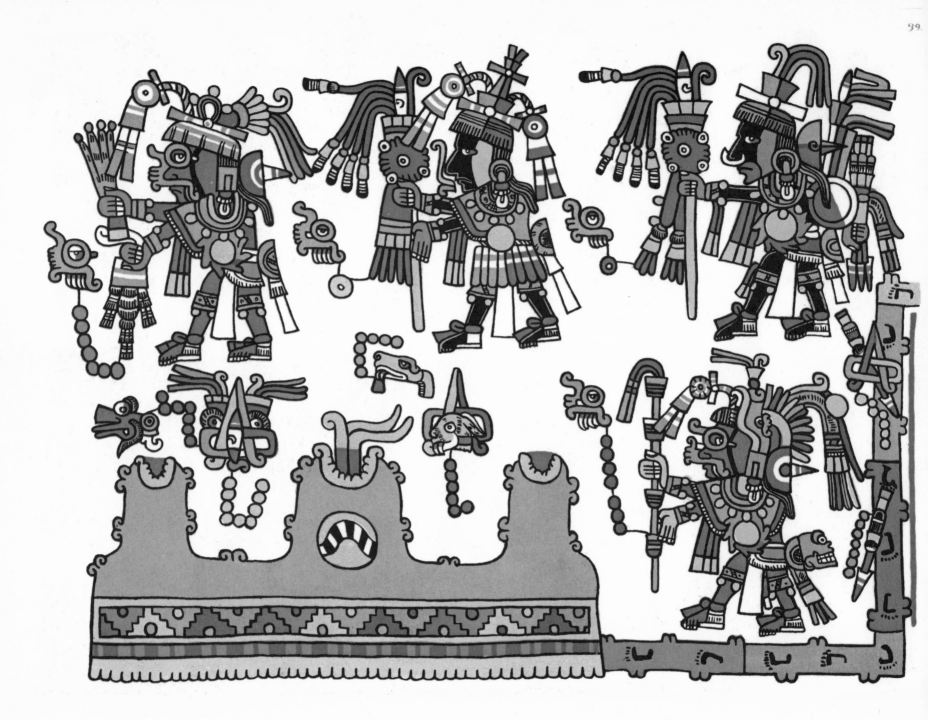

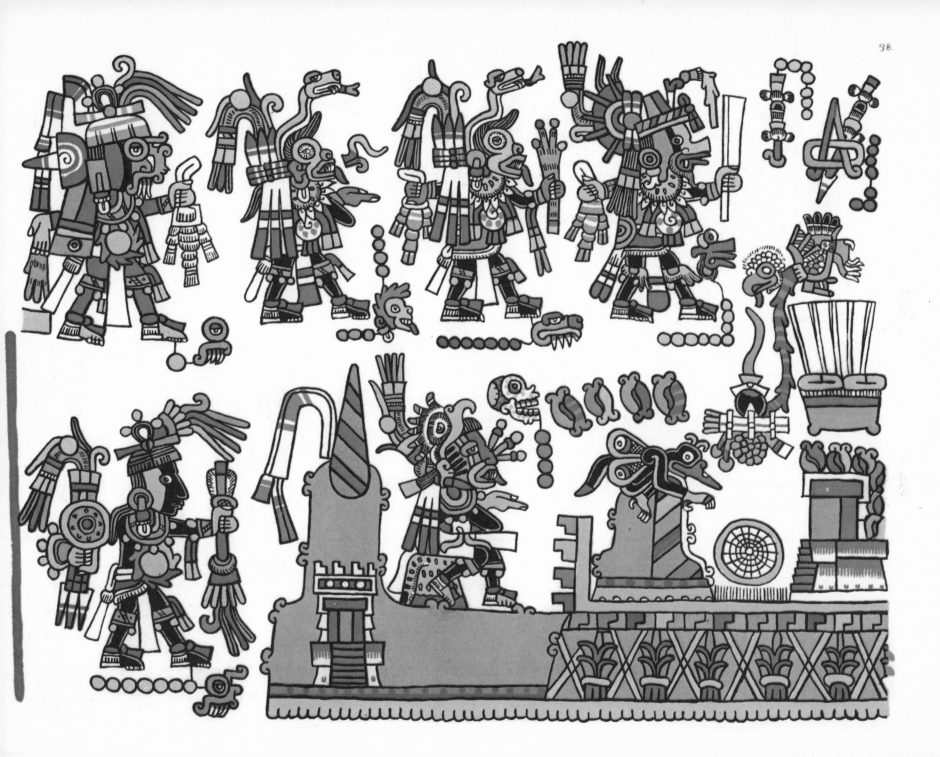

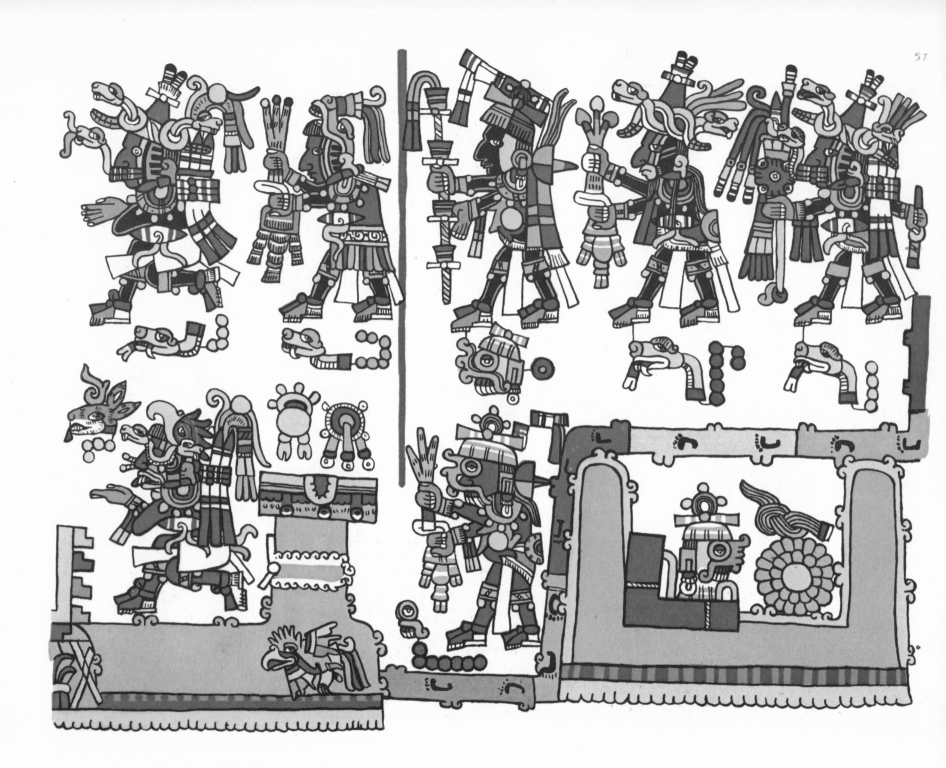

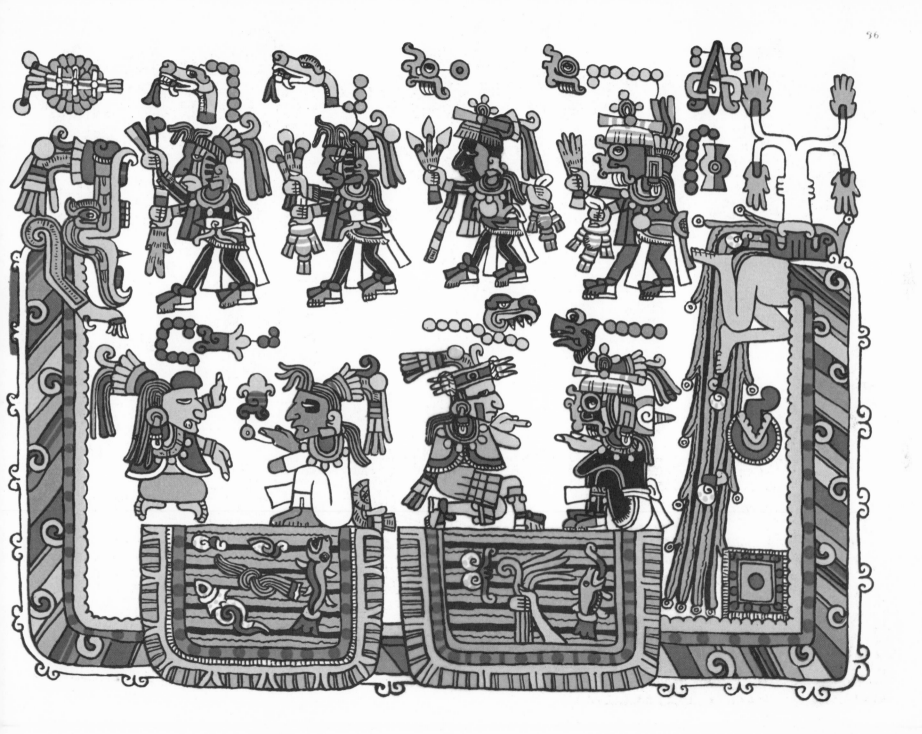

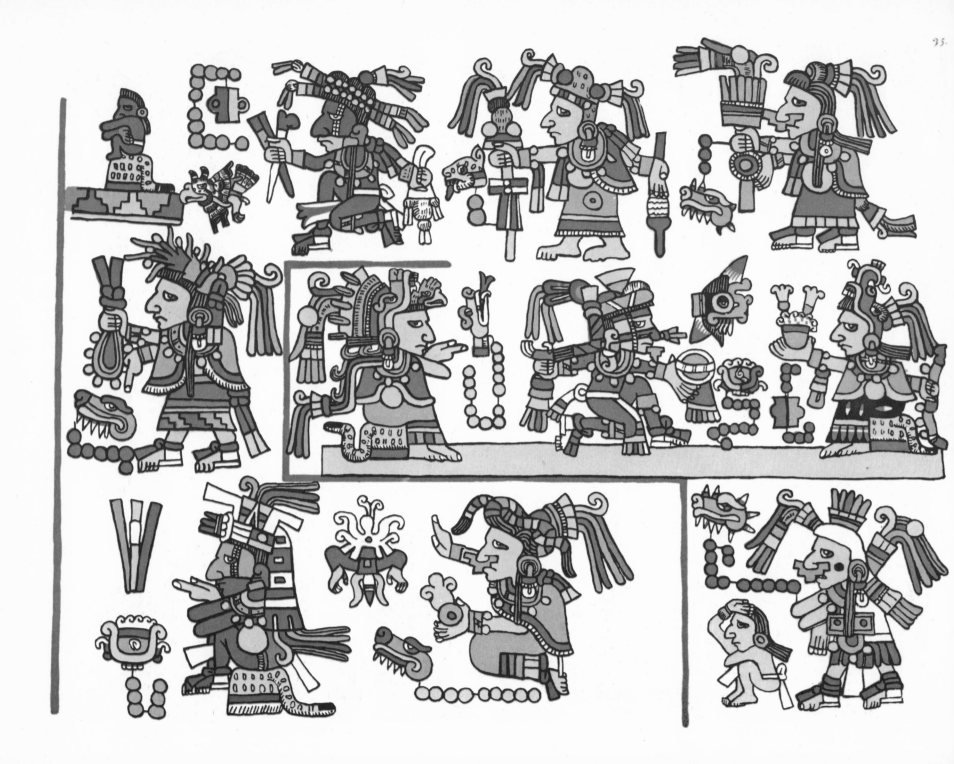

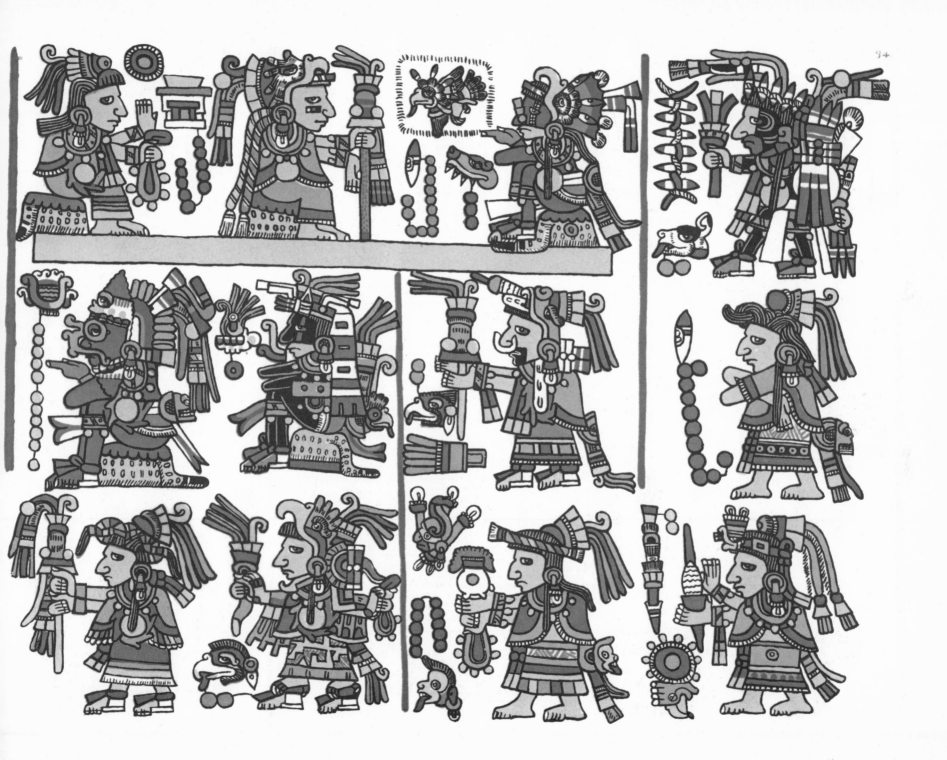

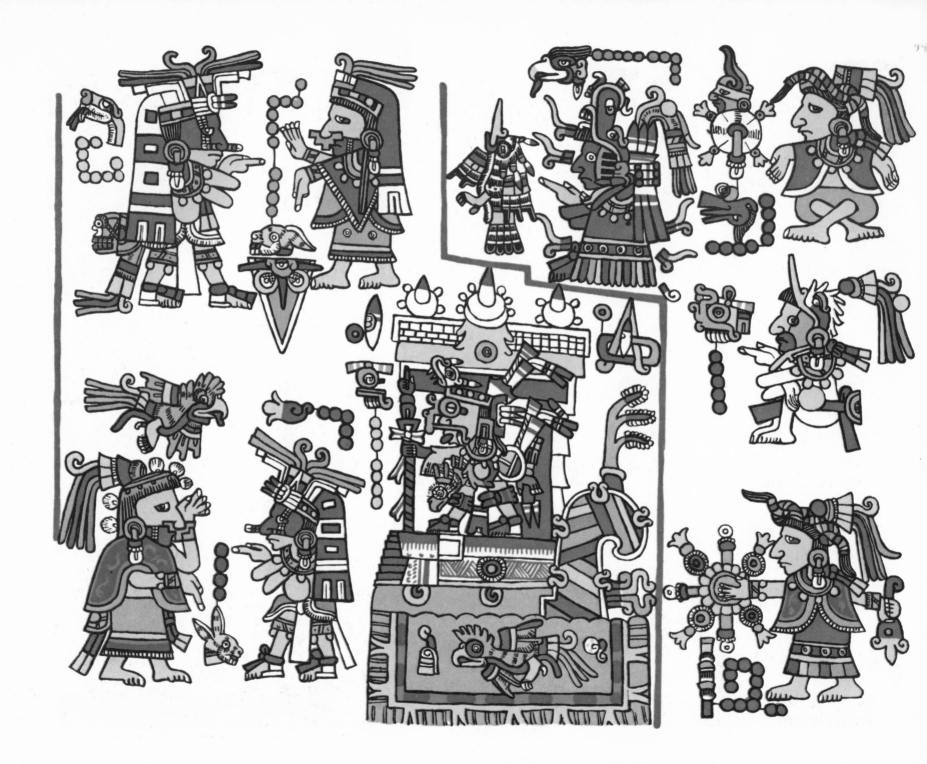

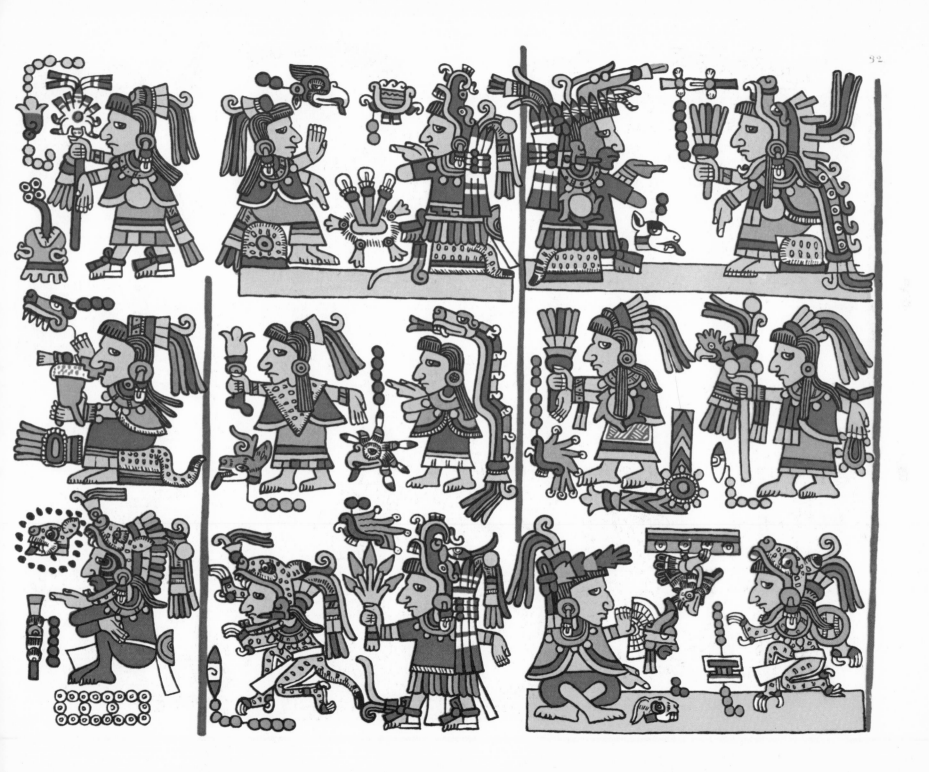

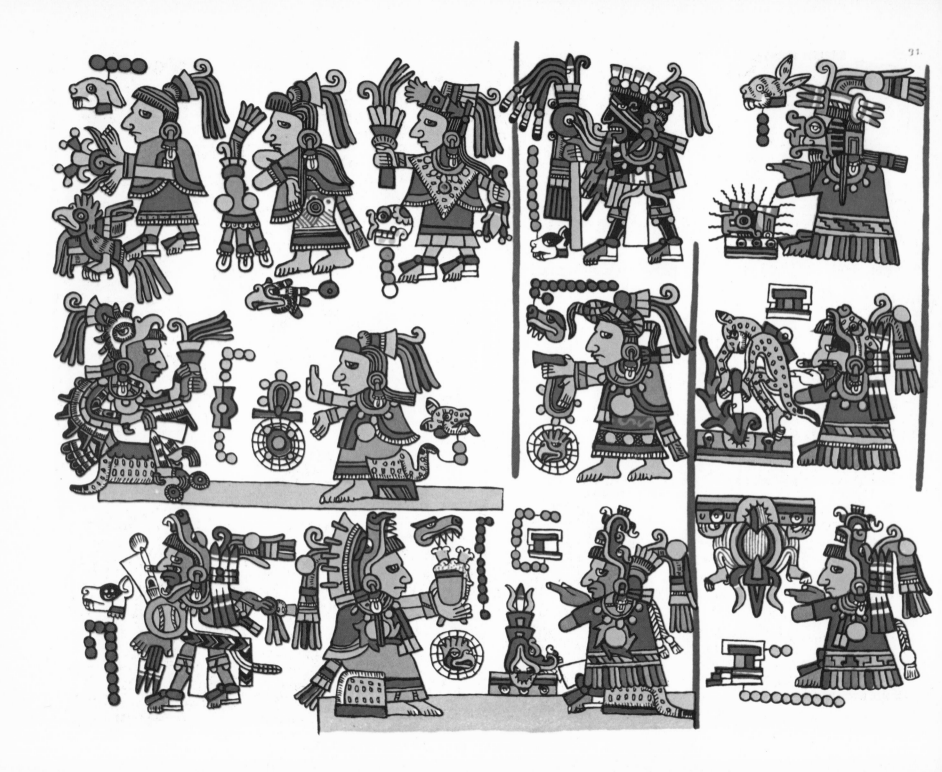

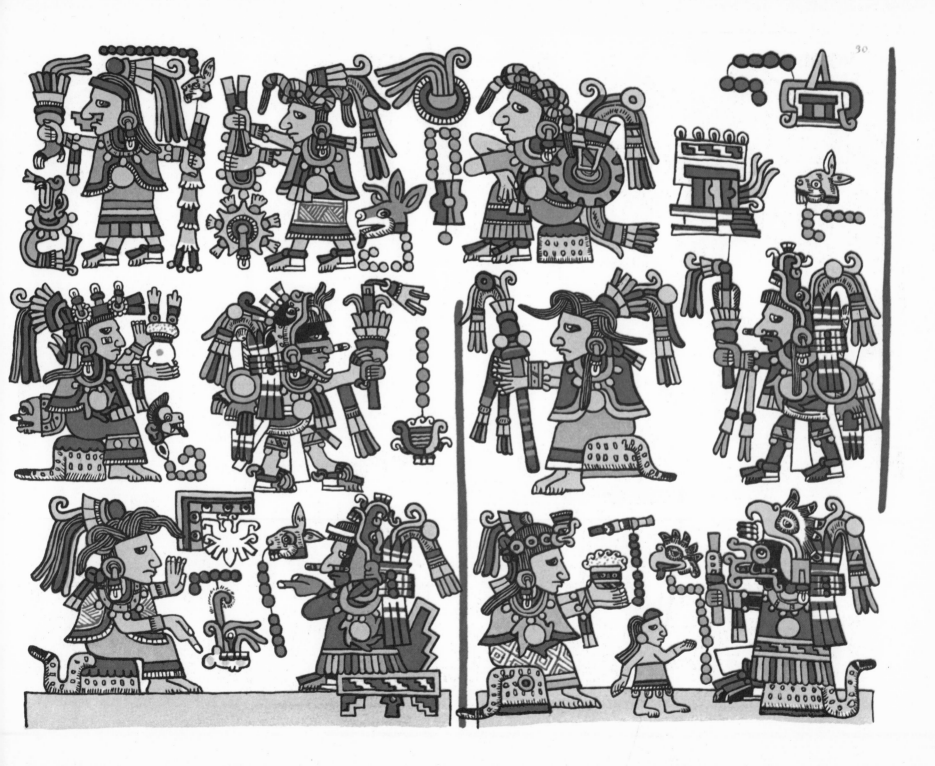

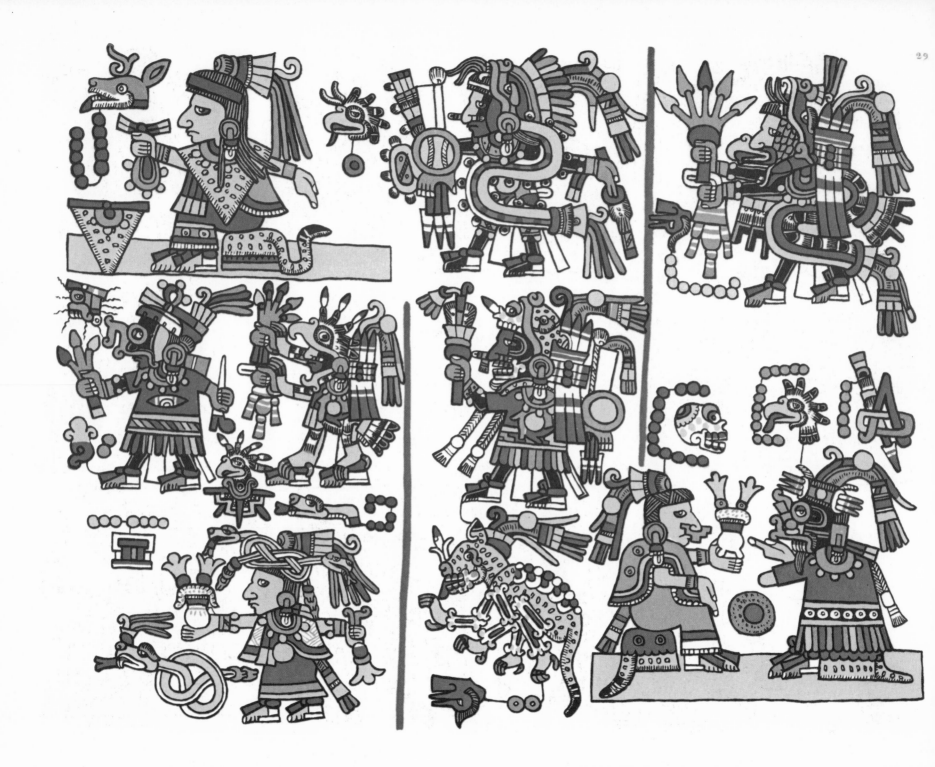

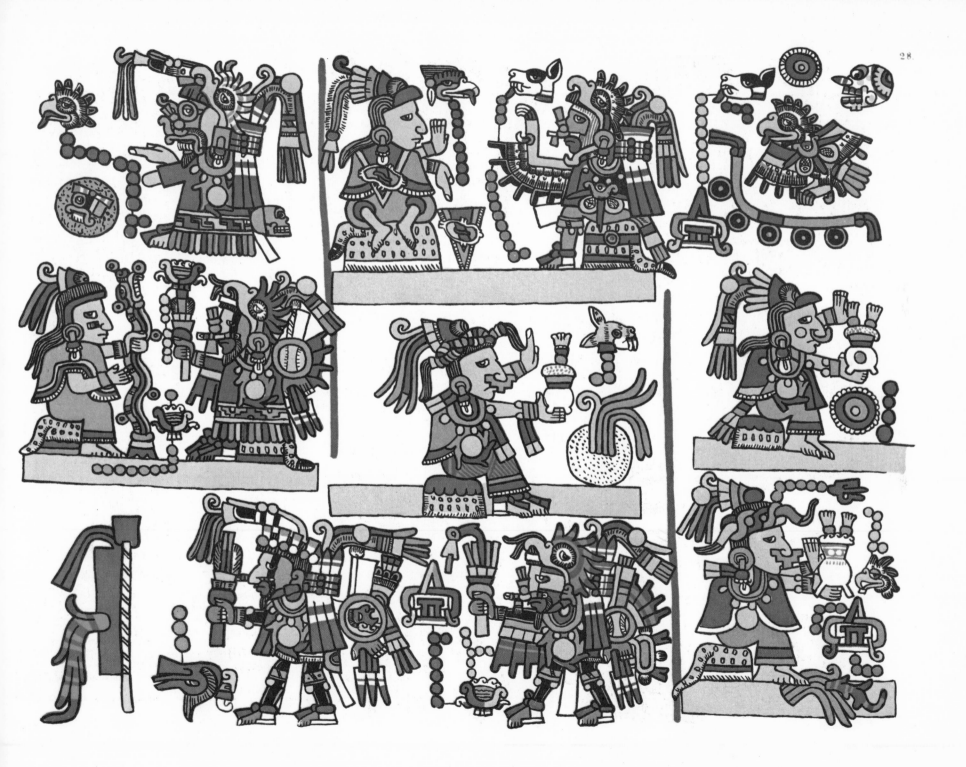

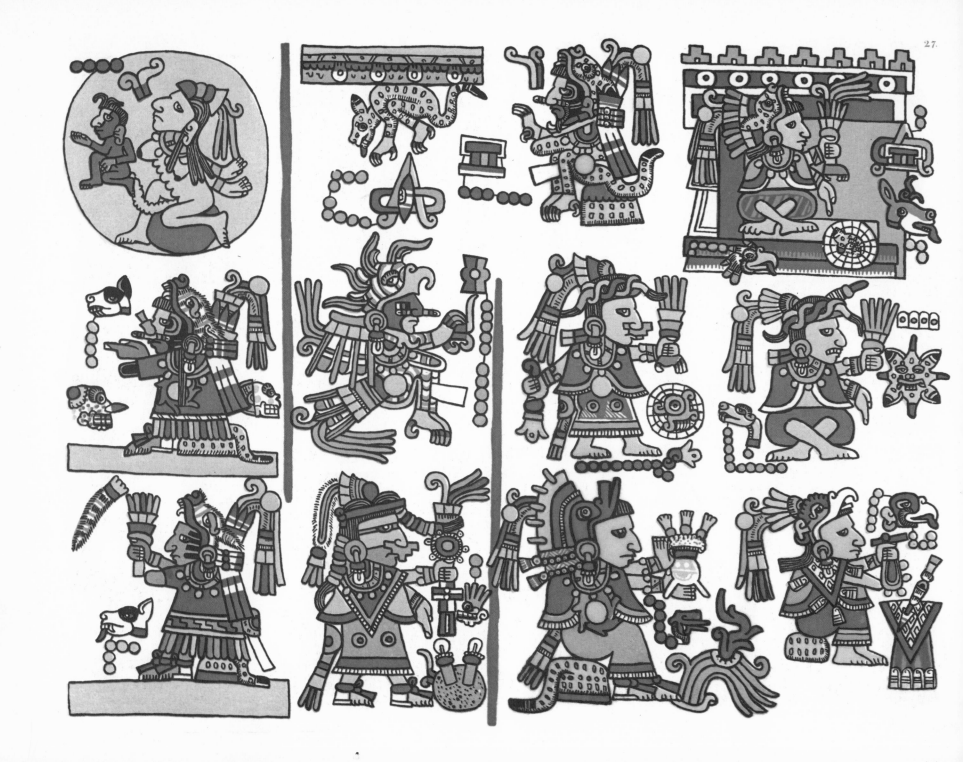

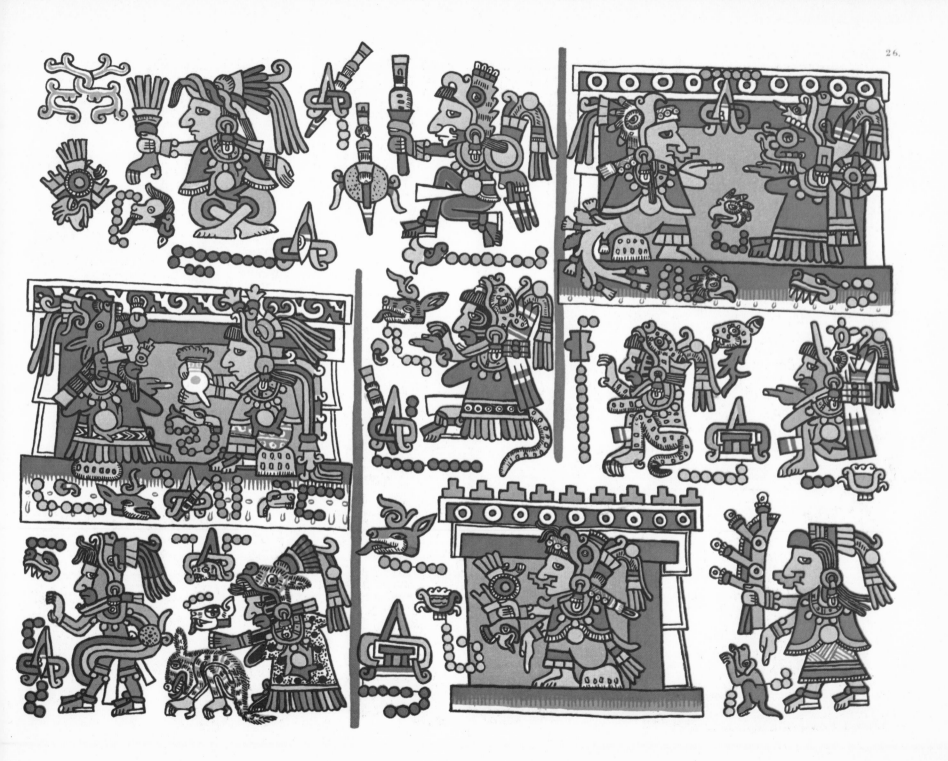

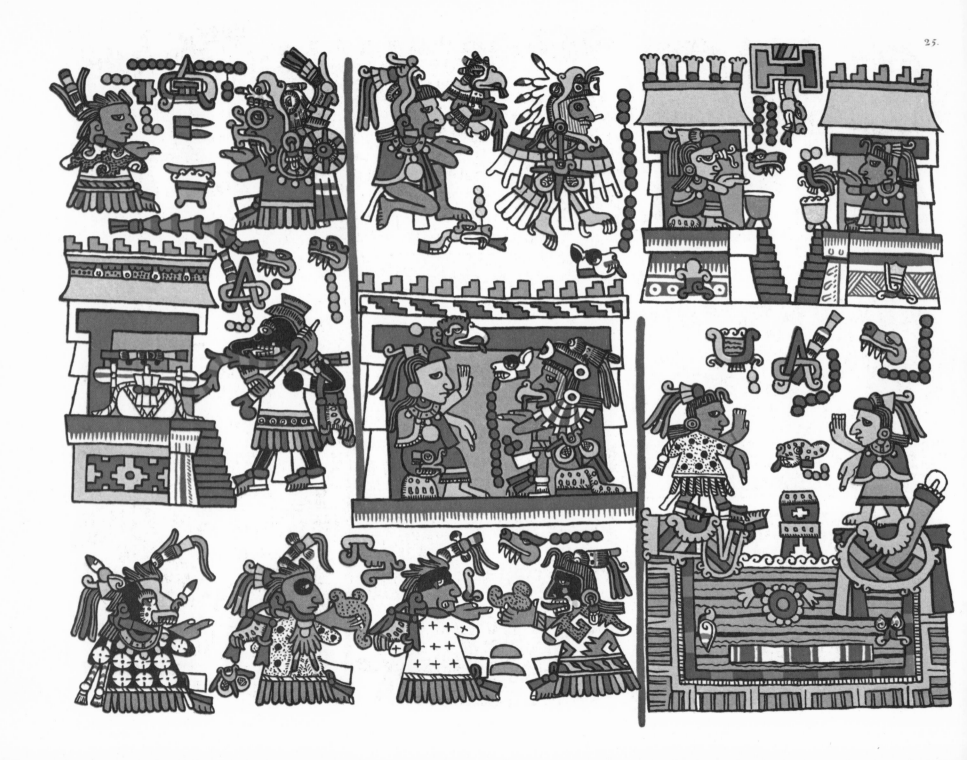

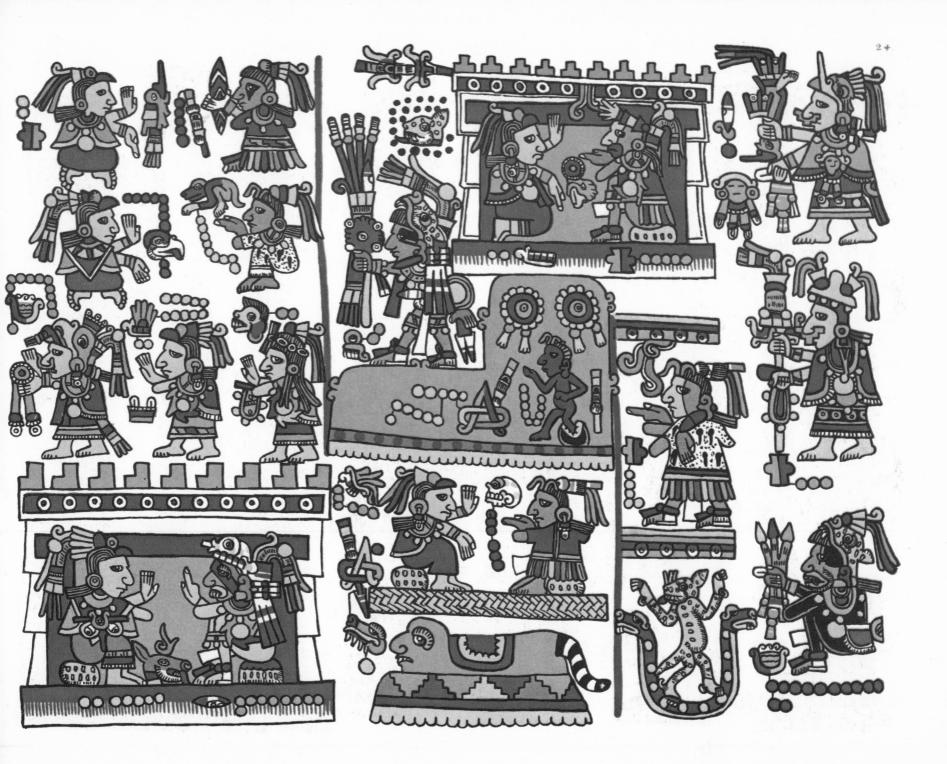

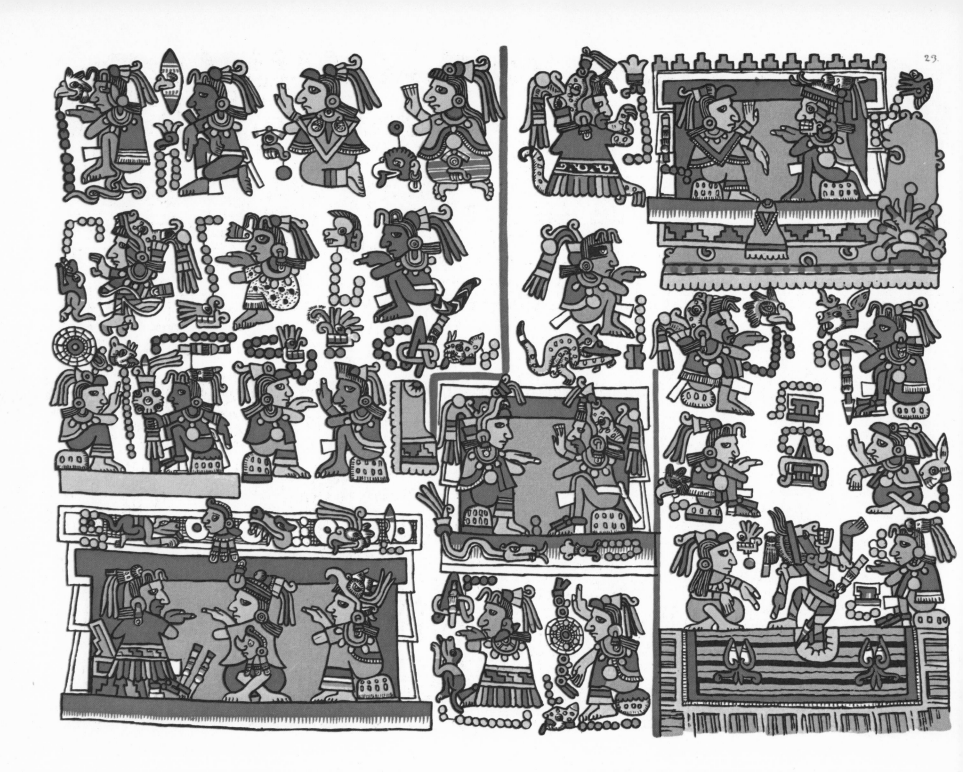

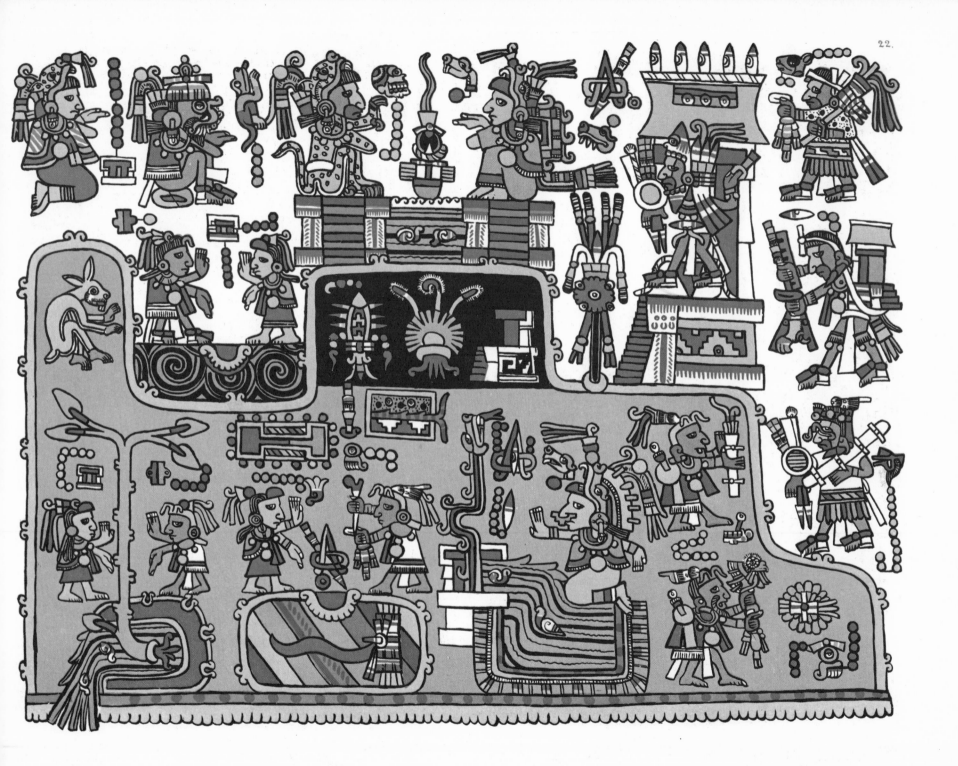

22.

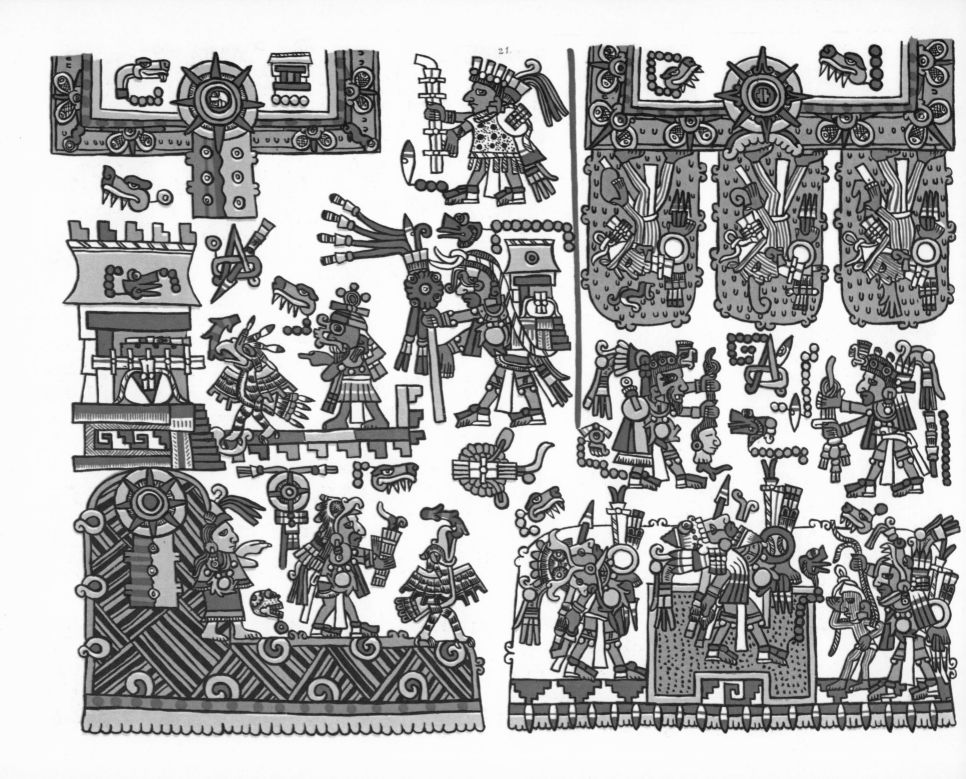

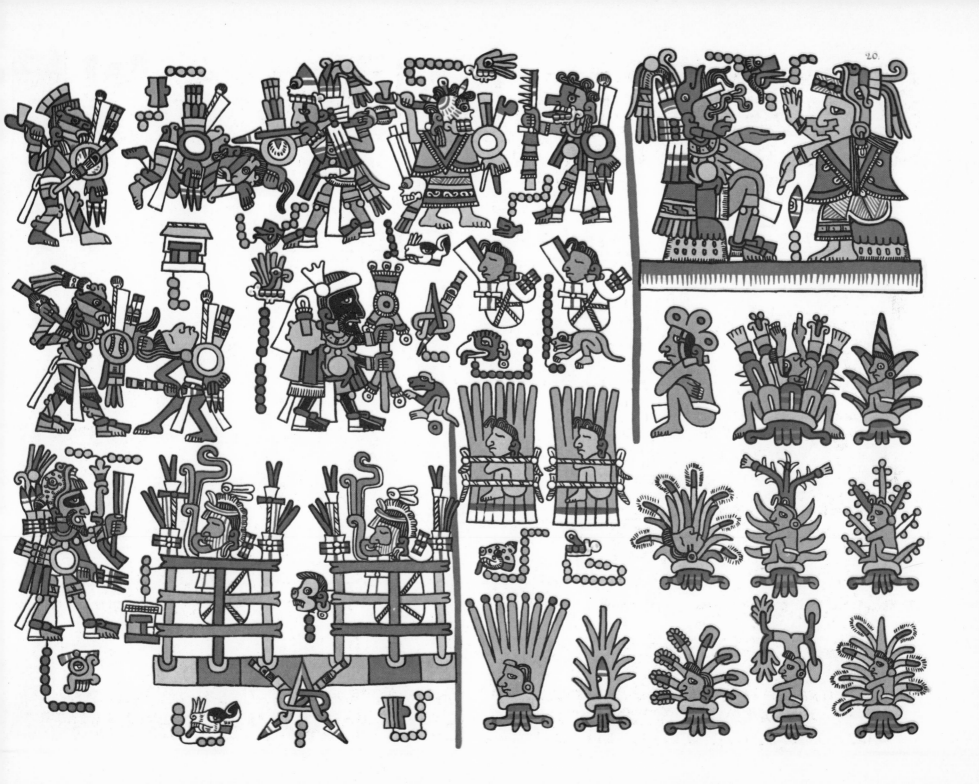

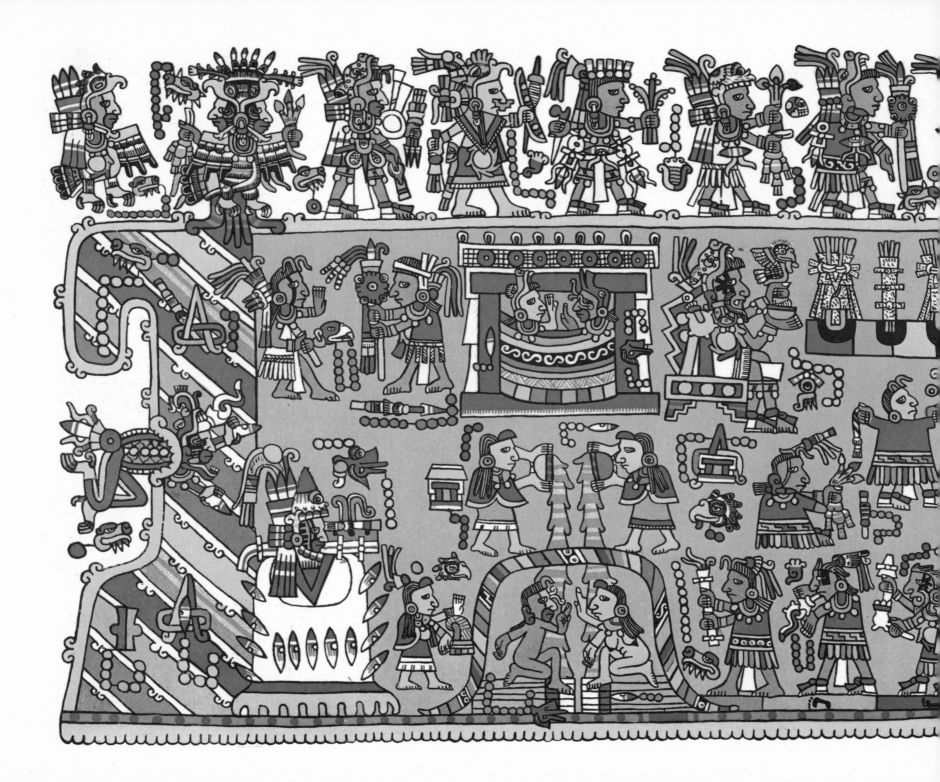

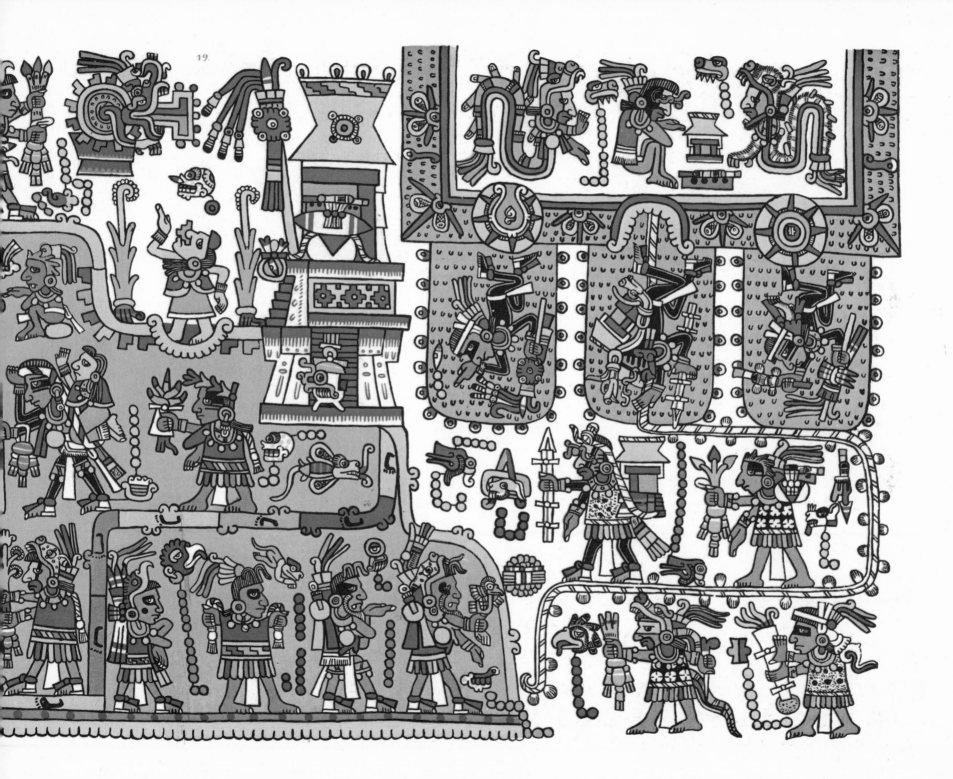

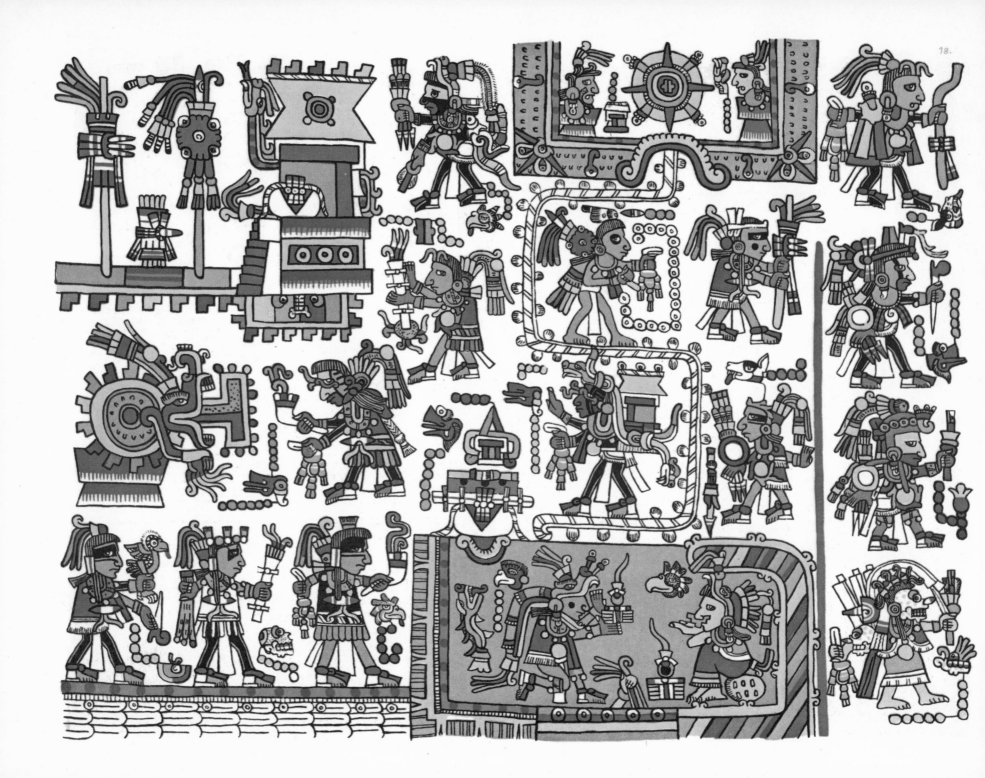

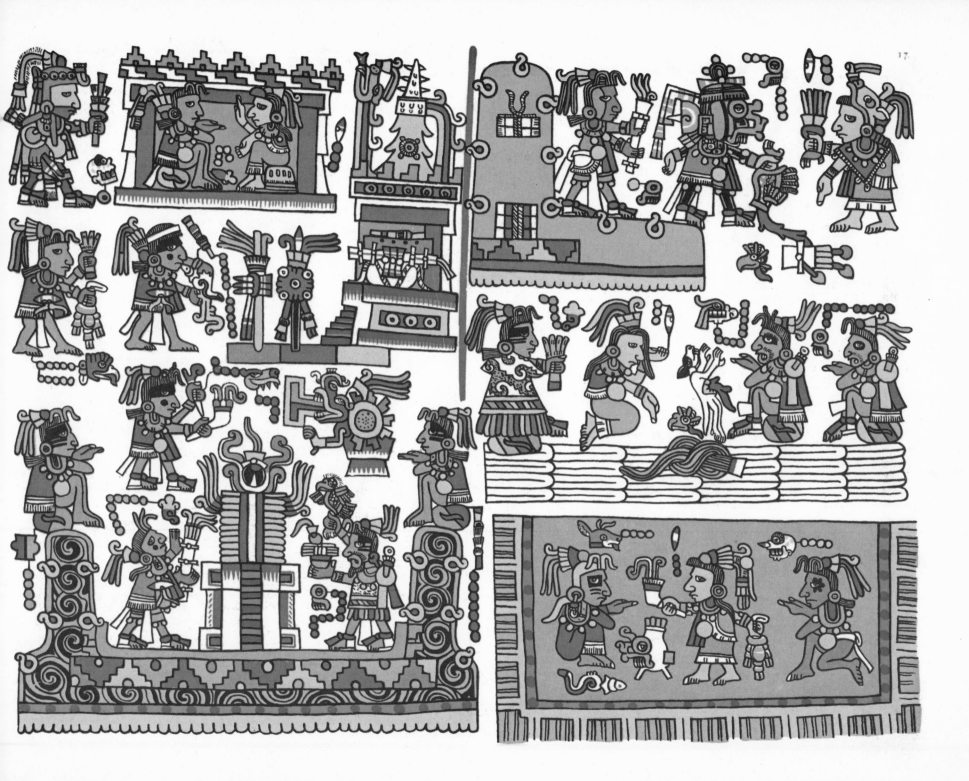

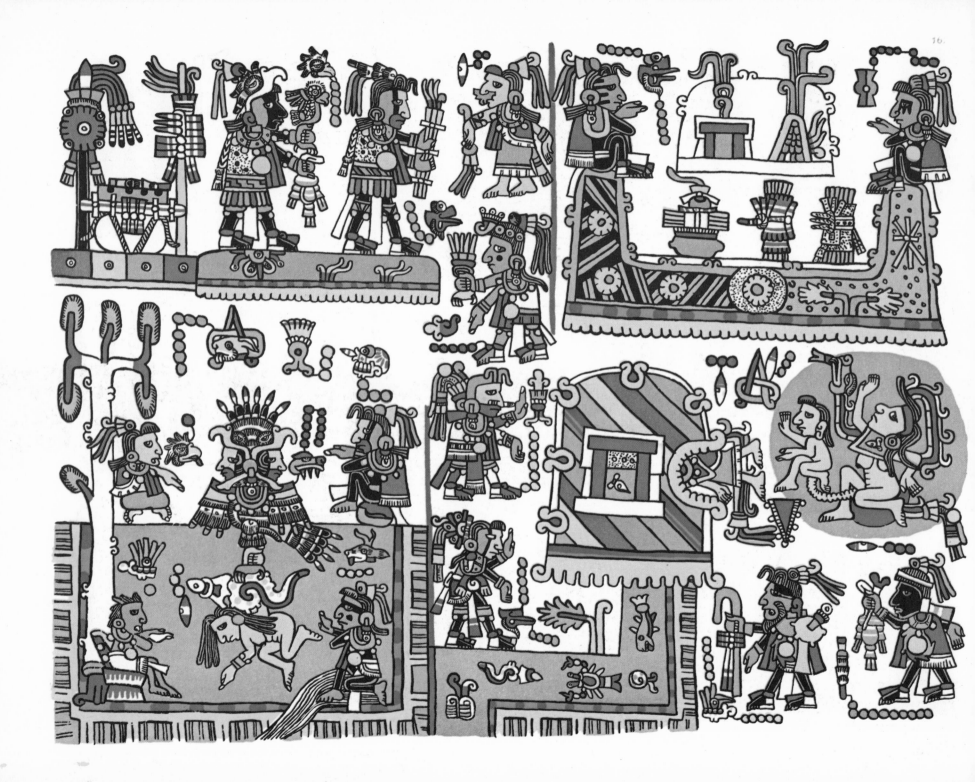

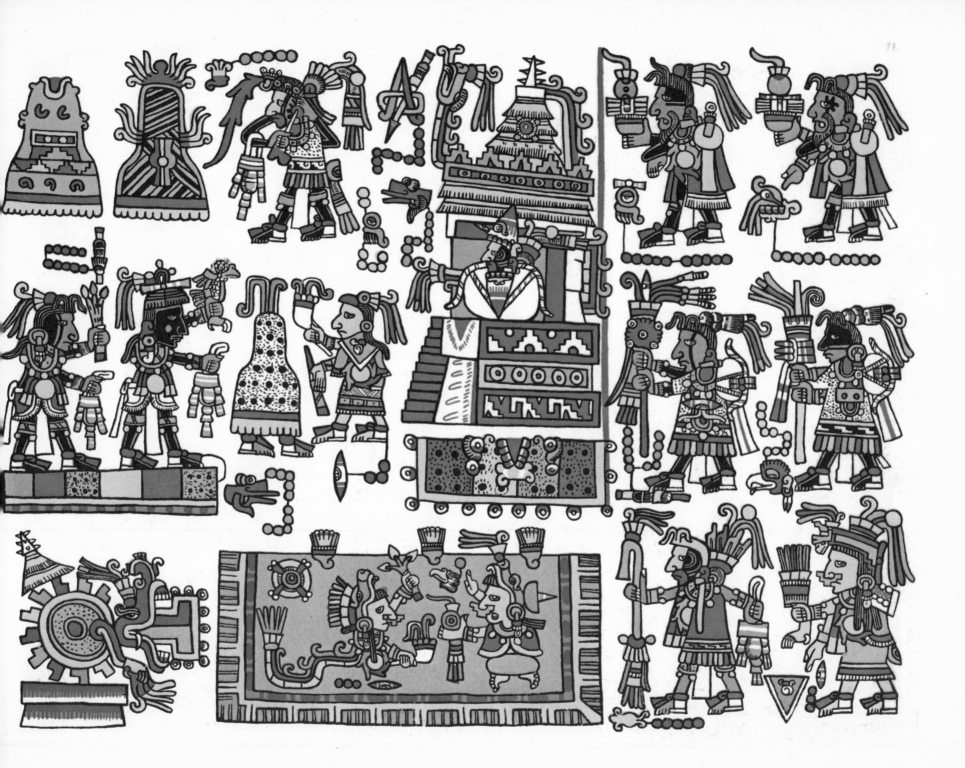

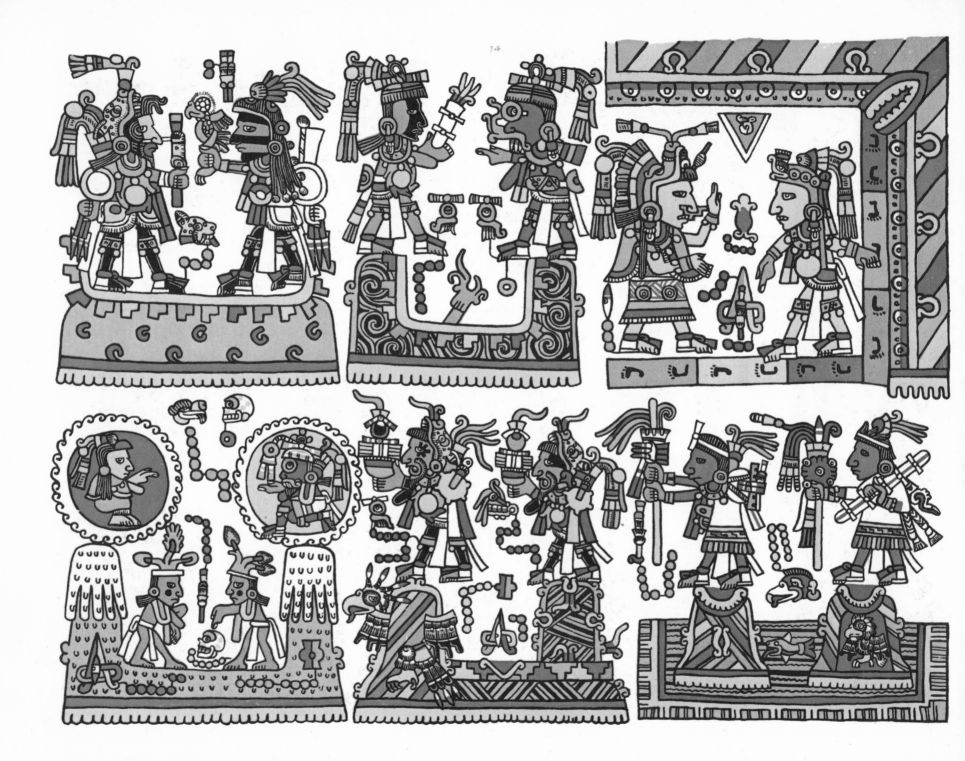

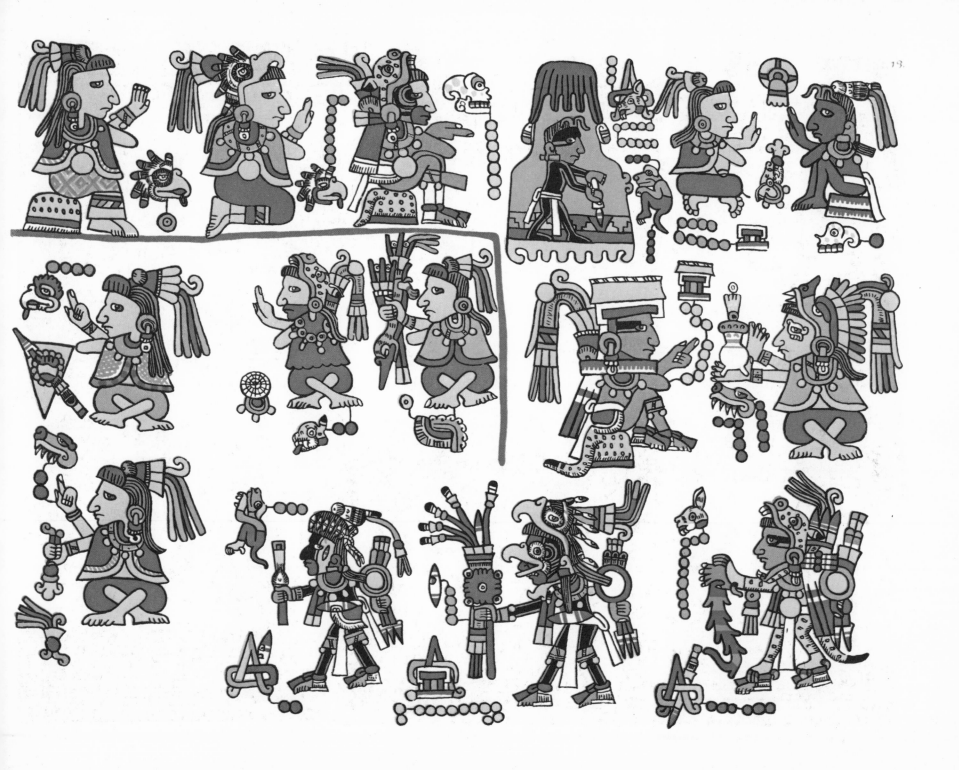

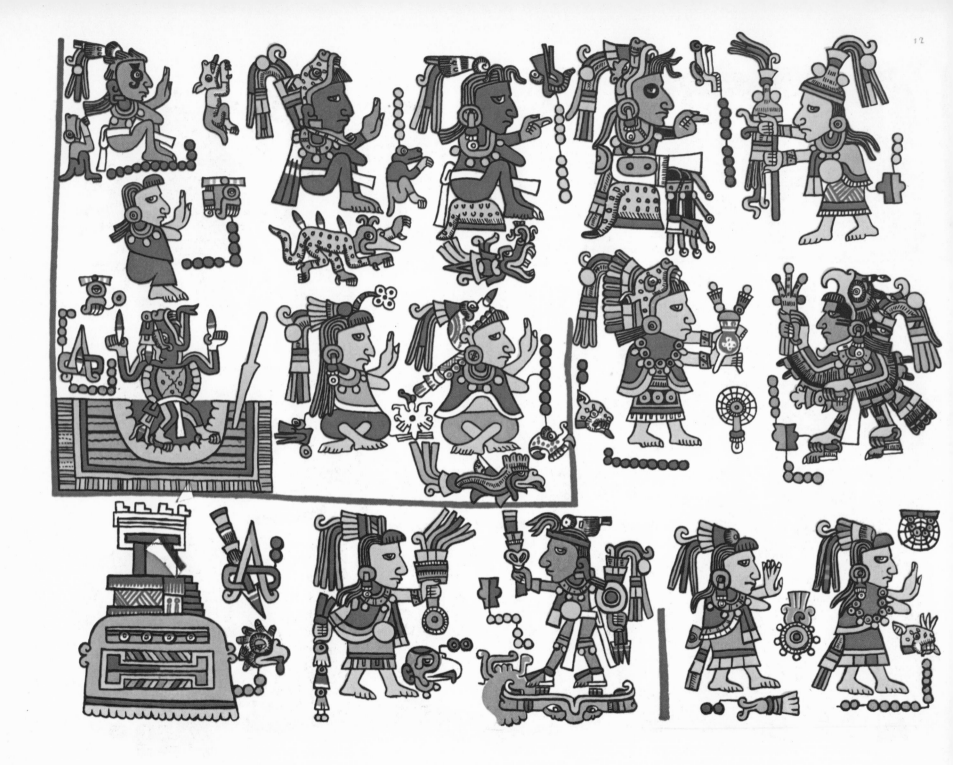

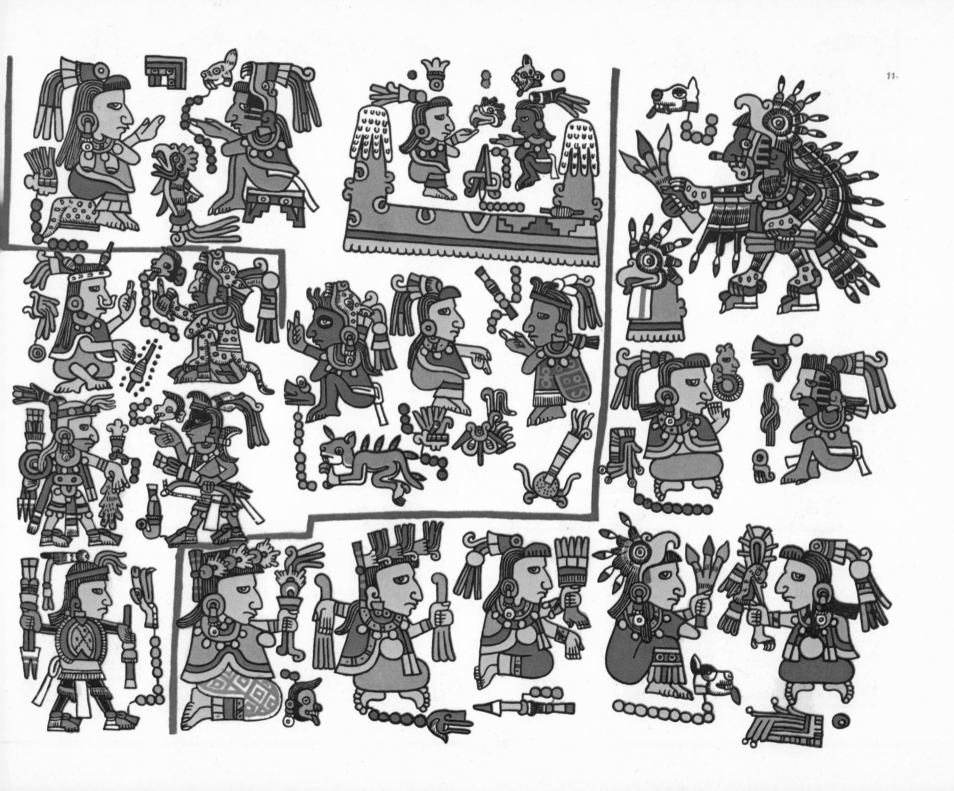

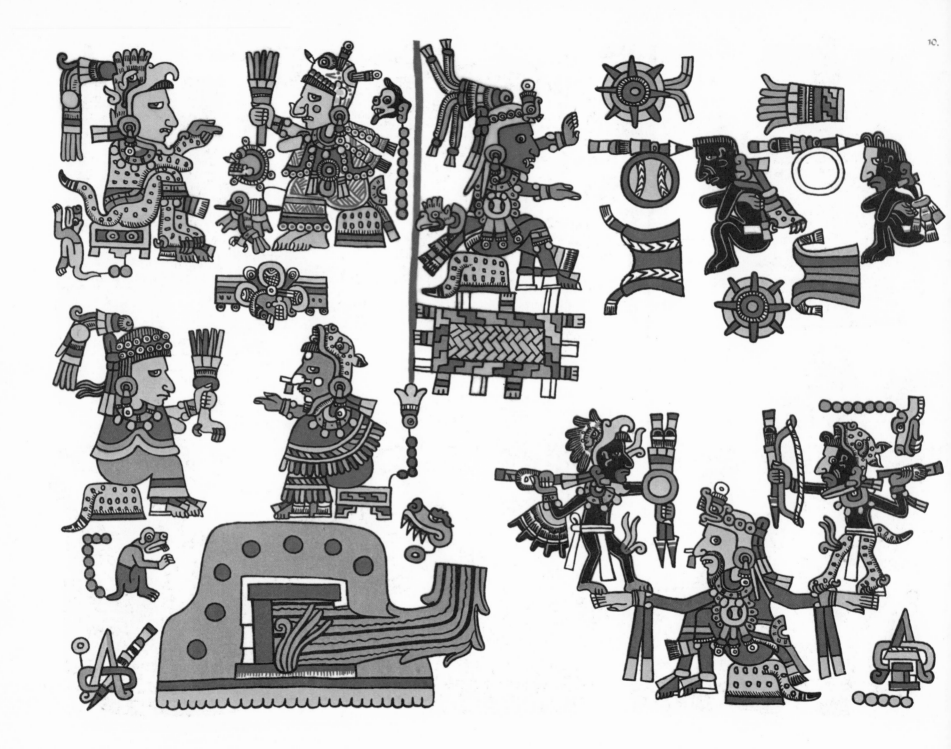

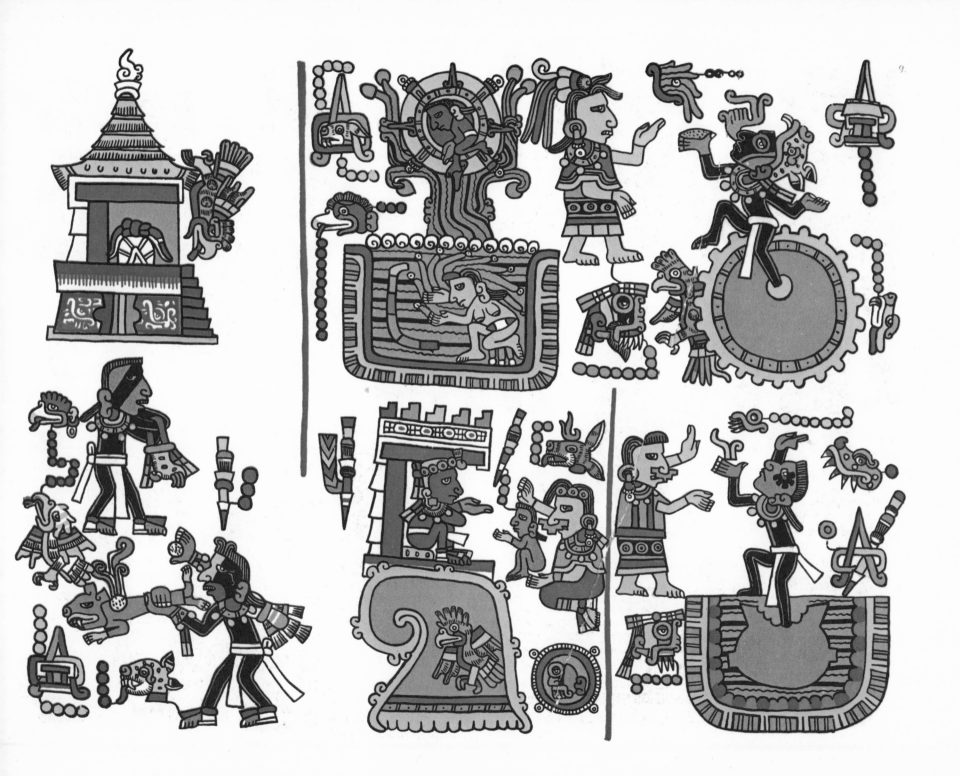

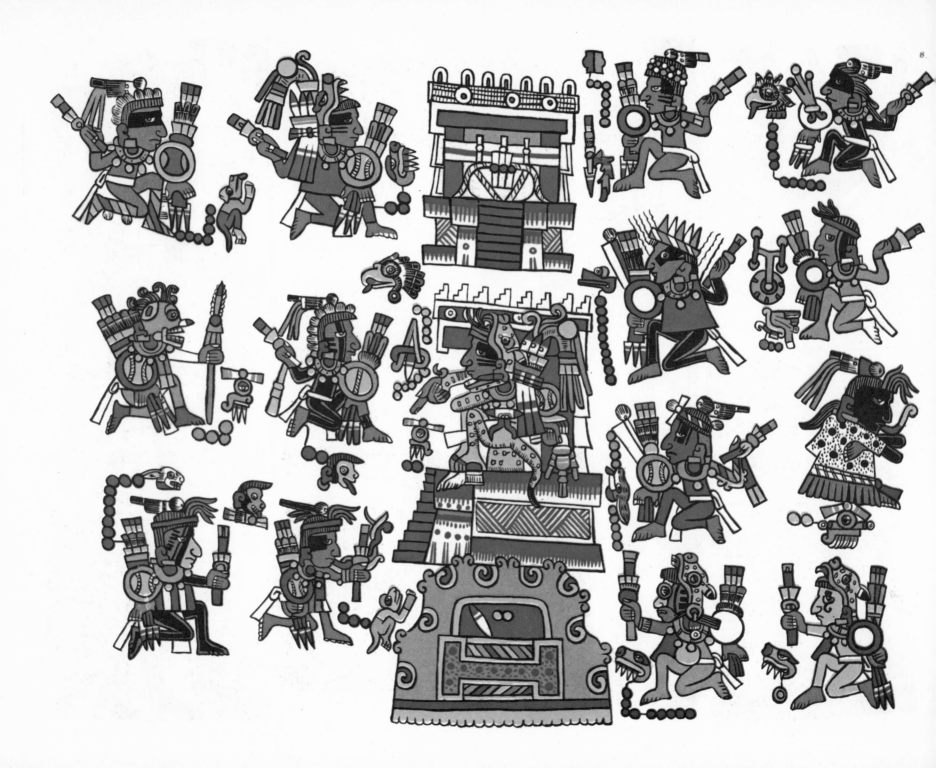

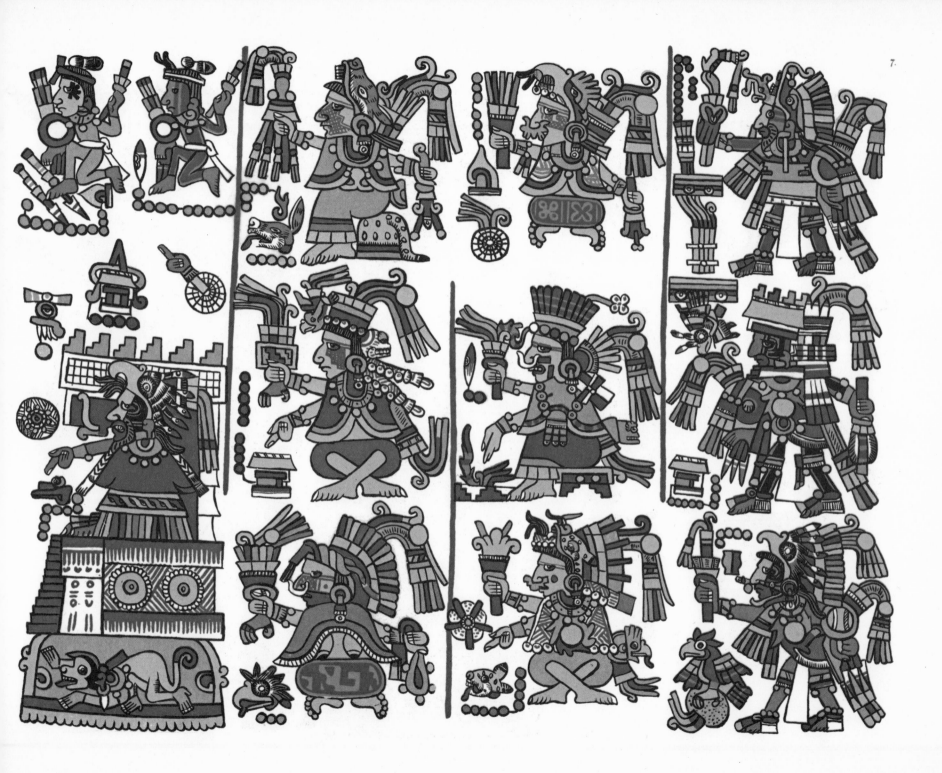

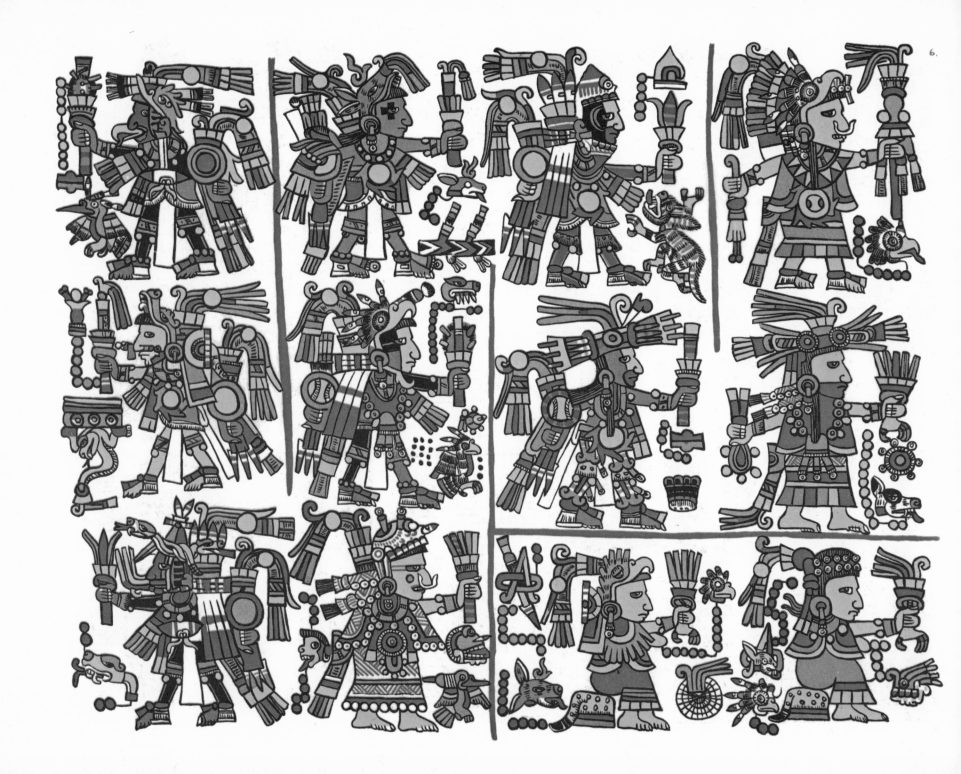

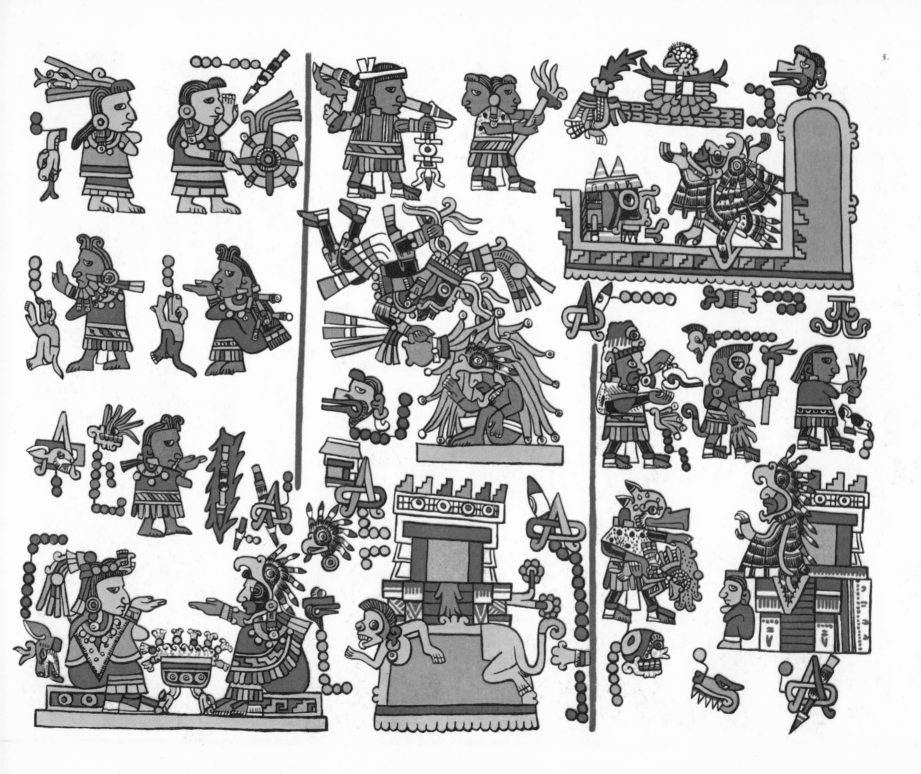

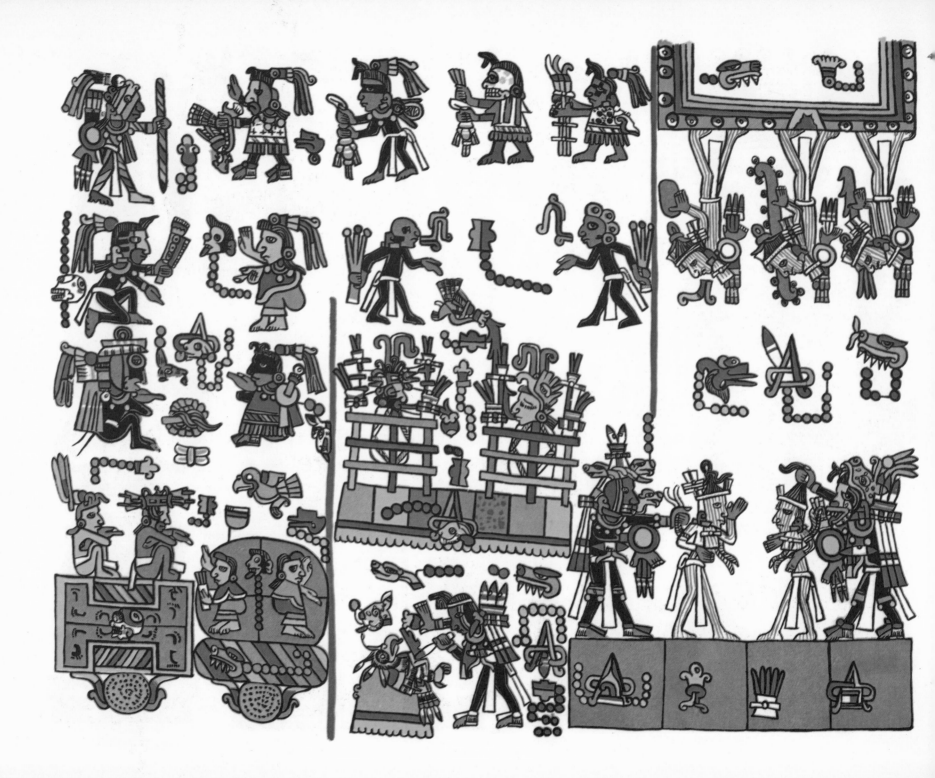

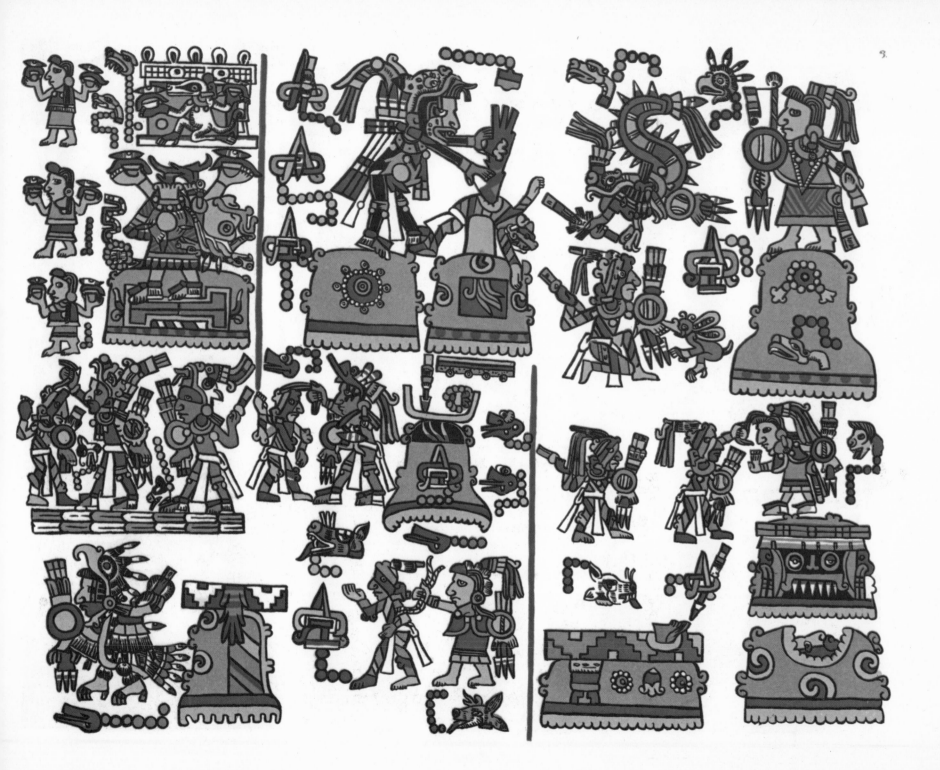

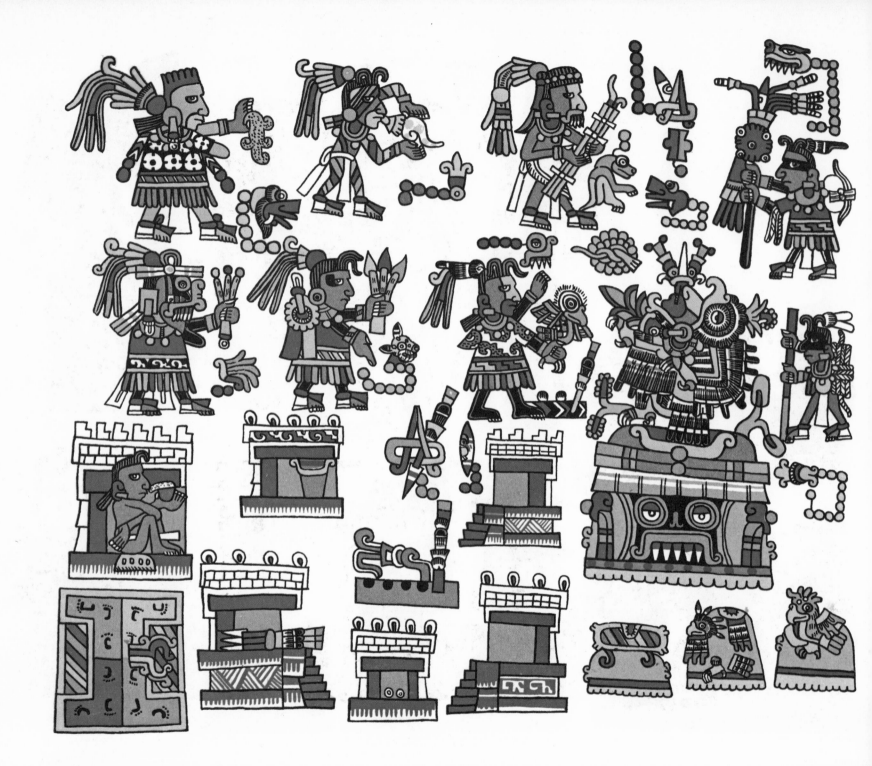